encaustic
REVELATION

CUTTING-EDGE TECHNIQUES FROM THE MASTERS OF ENCAUSTICAMP

Patricia Baldwin Seggebruch

NORTH LIGHT BOOKS
CINCINNATI, OHIO
ARTISTSNETWORK.COM

contents

HOT BONUS

For bonus demonstrations and an expanded participant
gallery, visit artistsnetwork.com/encaustic-revelation.

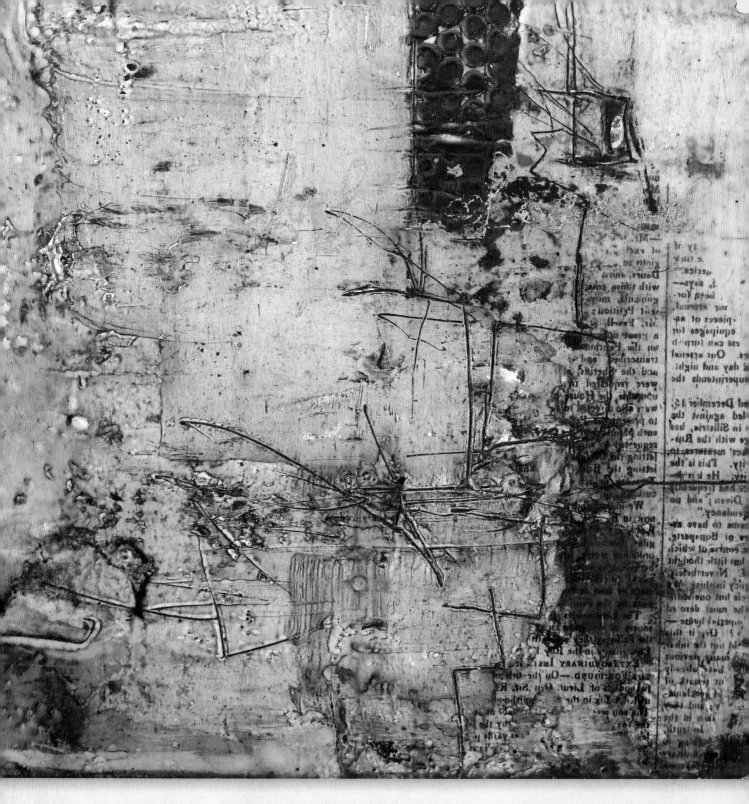

Lives with Loates

This piece comes from Australia. I loved this piece and couldn't part with it, even at the expense of its weight in my limited luggage! It found a new home in Tacoma, Washington, with Doug Loates and his family, and therefore is now known as *Lives with Loates*. Burnt Umber pigment-stick glazing gives this dyed, encausticized, incised collage painting its final patina.

what you'll need

Don't feel like you have to acquire all of these products at once. Start with the basics and then build your tool chest according to those projects that most catch your eye. Invite a friend or two to join you and share tools and materials, collaborate and have fun.

acrylic or fabric paints

acrylic plates

Akua inks and modifiers

Akua wiping fabric

alcohol inks

aluminum foil

anodized aluminum plate

baby wipes

black patina

bone folder

brayer

bristle brush

bucket of water

burnishing tool

chalk

charcoal or graphite stick

cheesecloth

Chinese ink brushes

cloth

coconut oil

cold-pressed watercolor paper

color duster brush

cooking oil

copper tape

cotton rope

cradled panel

damar resin

decorative wire

Diamond Glaze

Discharge Paste

dry pigment additive

Dye-Na-Flow fabric paint

egg carton

electric skillet

encaustic paint or pigmented beeswax in your color choice

Encausticbord

Enkaustikos C-Series Hot Pen attachments

Enkaustikos Hot Brush attachments

Enkaustikos Hot Cakes encaustic paint

Enkaustikos Slick Wax

Enkaustikos Writers: Batik Writer, Wax Max, Wax Writer

EPS foam

etching press

felt

foam brushes

freezer paper

gesso

glass cleaner

glass pieces

gloves, latex and vinyl

Golden Acrylic Glazing

hake brush

hand drill

heat gun

heat-safe work surface for soldering

heavy gel medium

hog bristle brush

hot palette or griddle

hot pot

hot wax medium

India ink

inkjet prints

iron

Jacquard Indigo Tie Dye Kit

Jacquard Pearl Ex pigments

Jacquard Procion MX dye

jump rings

knife or ulu

loaf pan

Lutradur

mark-making tools

mask

metal file

metal polish

necklace chain or earring hooks

needle tool

newsprint

oil paint and additive

oil pastels or Caran d'Ache crayons

oil pigment sticks

paint stir sticks

paintbrushes

painter's tape

paper cutter

paper towels

paste flux

Pearl Ex Pigment Powder

pigmented medium

plastic ice cube tray

Plexiglas

Pliers, flat-nosed and bent-nosed

polyester fabric

pottery loop

printmaker's tin

raw wood panel

razor blade

release agent

Rigid Wrap Plaster Cloth

sal ammoniac

scissors

scraping and carving tools

seed beads

self-adhesive paper

sewing needle

shaping tools

silk habotai, silk organza

small wooden box

solder, lead-free

soldering iron and stand

sponge

spray bottle

stapler

stencils

stretched canvas

sumi paper

tabletop vise

tjanting pens

tjanting tools

tweezers

twigs, leaves, bark, etc.

Tyvek

watercolors and watercolor brush

wax glaze

wax paper

wax stamping tools

wax thermometer

wax tools

waxed linen thread

wood blocks

wood glue

wood-burning tool

Yes! Paste

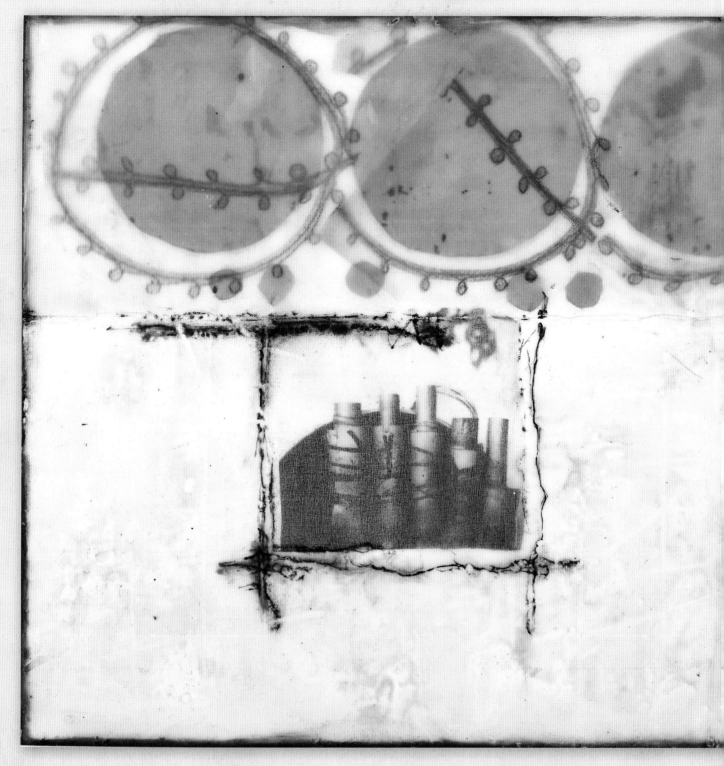

HOT BONUS

For a bonus demonstrations, art and more, visit artistsnetwork.com/encaustic-revelation.

To the Queensland Sandy

This piece has a deep, saturated Indigo dyed initial layer that I covered with Titanium White encaustic paint in all but the three circle areas, which were masked off with self-adhesive paper. Onto this I added collage elements and incising before calling it delicious.

introduction

EncaustiCamp is my fifth child—that is, if I don't count the books. Just like each boy was a notion in my head, just like they each were seeded by the encouragement from someone else, just like they were closely monitored in incubation and needed certain special care in the months before coming to be born, so too did EncaustiCamp come to be.

And now, as I look forward to its fourth year—with many more to come—I realize how it is even more so my child. My boys may have moved into lives of their own in the world, but I still have children to raise! EncaustiCamp is my greatest creation next to the four gingerrangas, and it is with proud-momma joy that I bring it in a small way to you with this book.

In autumn 2010 I asked a workshop group at Sitka Center for Art and Ecology in Oregon one of my early "what ifs." I asked, "What if a retreat were to happen—like the ArtFests, the Art and Souls, Art Unraveleds—but all encaustic? And all inclusive? What if?"

With resounding enthusiasm the group gave a unanimous thumbs-up to the notion, and the seed of EncaustiCamp was fertilized. Thanks to Laura Lehman, the Western Mennonite School's vacant summer campus in Otis, Oregon, and the consistent, persistent encouragement of my first "I am all in!" instructors Crystal Neubauer and Michelle Belto, my nerves and courage stayed (barely) in check, and nine months later (yes, really!) the inaugural EncaustiCamp was underway.

Judy Wise, Bridgette Guerzon Mills and I rounded out the first-year team of five instructors. Sue Stover and Jessica Greene (standing in for Crystal who couldn't make it) made six of us the second year. Year three had us settling in with Crystal, Michelle, Judy, Sue, myself and the dimensional wonder of our first international reach, Canadian Shary Bartlett. It is this team plus our 2013 artist exposé instructors Amanda Jolley and Kathryn Bevier you will find in these pages.

I can't decide if EncaustiCamp grows each year or if I've been birthing a whole new creation each year;

it certainly feels like the latter with all the changes it's gone through. It is undeniably growing, though.

At three years old, it's living dog years, not human years, moving rapidly through childhood and adolescence to the confident, mature, layered personality and character of young adulthood. Alongside, as its mother, I am growing in confidence and wisdom in raising it as well (I haven't killed it yet!).

My hopes when I began—when it was still just the notion in my head—were for it to be a place where artists of every make, model and mode would come together uninhibitedly to work in all the dynamic methods of encaustic. I birthed EncaustiCamp so the art world would better see and therefore know that encaustic is what I continuously proselytize it is: a dynamic form of creative expression that holds unlimited potential to encourage everyone to their own creative voice. It is dynamic and all-inclusive.

And it is that inclusive nature that drives me back each year; I think I could no more give up on EncaustiCamp than I could one of my boys. The inclusive nature and my determination to show this to everyone are what cause me to look beyond the angst of creating a website, working forms in Excel (I detest creating forms!), wanting to quit—every single time—in the weeks just prior to the event from the waves of fear, dread and self-doubt that flood me and persevere. I stay true, remain steadfast, so I may reach more, teach more and inspire more through this unique retreat. Because yes, wonder and awe happen—every single time—at EncaustiCamp from the moment the first enrollee steps through the doors and we begin.

EncaustiCamp is its own being. And I am blessed—humbly, graciously, overwhelmingly blessed—to have given birth.

Come along and meet him, here in these pages. You won't regret who you find. And should this inspire you to ask yourself your own "what if," then come along to EncaustiCamp.

You. Won't. Regret. It.

In love,

—Trish

Cross to the Other Side

Cross to the Other Side was painted at EncaustiCamp 2013! I love when the energy of place comes through in a finished piece, which is rare. This began with plaster on a cradled art panel, followed by tjanting marks and indigo dye, before incising, the predominant technique in the encaustic, to finish it.

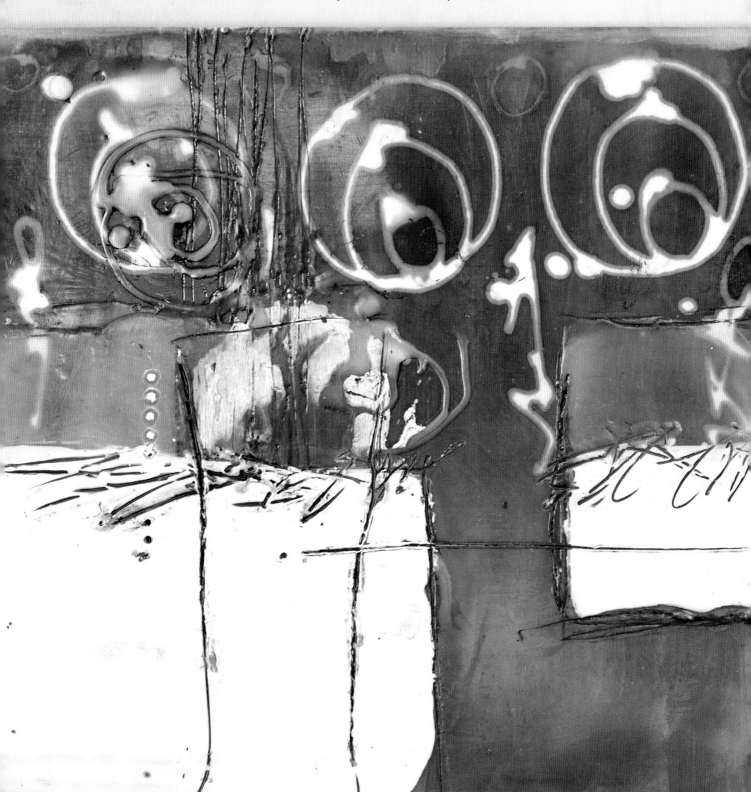

tools and materials

Often artists shy away from beginning in encaustic because they fear a costly investment to get started or a messy setup that will take over their studios. Neither fear is warranted. The cost can be kept minimal by investing in products from home stores or hardware stores (which work just as well as more specialized products), and the mess is nonexistent. The product is self-contained in its cooled state, and all tools and surfaces can be cleaned by simply melting the wax away. In fact, if you're using brushes and other tools specifically for this medium, they need not be cleaned at all!

You need only a few basic essentials to begin encaustic painting. I've listed them here, along with a few of my favorite tools, to get you started. As you begin to explore the techniques in this book, you will realize that the possibilities for tools and materials compatible with encaustic are endless. Anything goes! After you master working with the basic elements of the medium, the sky is the limit.

WAX

Refined beeswax is the standard in encaustic painting. It has been treated to remove the natural yellow of the beeswax, and it produces a clear, glass-like finish when used with or without damar resin. Refined is a better choice than bleached beeswax because the bleached wax can yellow over time due to the chemical processing it's gone through.

Natural beeswax is a gorgeous choice for rich, organic painting because it is still in its natural, yellow state, and it lends that quality to the finished work.

Damar resin can be added to the beeswax to give durability and luminosity to encaustic painting. Some artists work strictly in beeswax and still obtain durable, luminous results.

Medium is the term applied to this blend of beeswax and damar resin. You can make your own; proportions vary, and I encourage experimentation for the best medium for your usage. The standard ratio is 85 percent beeswax to 15 percent damar by weight. I highly recommend pre-made medium for ease of use. It is found through art supply stores in the United States and Canada, and is becoming more widely available in Australia, New Zealand and the UK, as well as through numerous online resources.

Here you can see the difference in appearance between natural beeswax (top) versus refined clear medium (below).

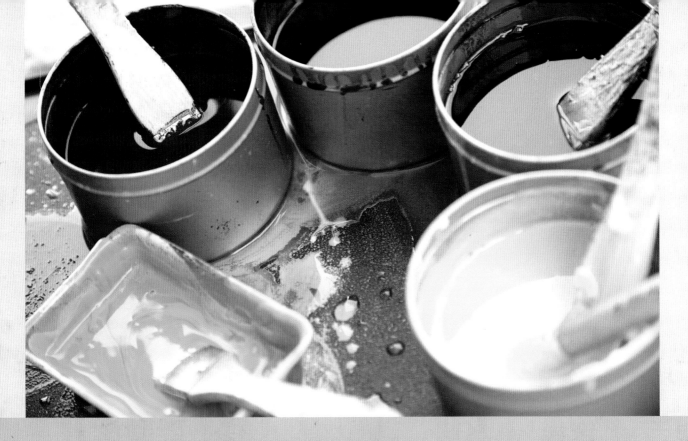

This typical palette setup features printmaker's tins filled with colored wax and uses a simple pancake griddle. Remember to use a palette thermometer to help monitor the wax temperature.

PALETTE AND TINS

In encaustic work the palette is where the wax is melted, mixed with colored pigment and kept fluid. Any flat surface that can be heated will suffice as a palette, but it is important to have a regulated heat gauge—rather than one with simple low, medium and high settings—in order to control the wax temperature. Barring this, the palette temperature needs to be between 170°–210°F (77°–99°C) for optimal melted wax temperature. A palette thermometer can help you regulate this until it becomes second nature.

Two great palette options are an anodized aluminum palette designed specifically for this purpose or a simple griddle from the small-appliance section of any home store. The anodized aluminum palette is great for mixing colors directly on the surface because it has a clear surface that maintains true color representations in mixing. But this surface does require a separate electric stove element placed underneath the palette to heat it. The griddle is inexpensive, has a nice large surface area and heats evenly and quickly upon finding the right temperature setting. I've always used this option, and I supply them in bulk to EncaustiCamp.

The cleanest and most efficient way to have multiple colors of wax melted at one time is to use tins arranged on the palette to hold different encaustic paints. I prefer 16-ounce (473ml) seamless printmaker's tins, but anything similar would also work. I have found these cans to be indispensable in my encaustic setup because they allow for large volumes of wax to be always at the ready and for my brushes to remain upright in their designated cans. You can mix a different color in each one, and if you need just a small amount of a color, you can use the lids to mix limited quantities.

The palette setup described here is wonderful for easy cleanup; just turn everything off and let it cool down and solidify. When beginning again the next day, simply plug it in, wait for the wax to melt and start painting.

For bonus demos, art and more, visit artistsnetwork.com/encaustic-revelation.

When the wax is completely melted on the typical palette setup, simply assign a natural bristle brush to each color for easy painting and hassle-free cleanup.

FUSING TOOLS

Fusing is the reheating of each applied layer of wax so it bonds with the preceding layer, thus ensuring a cohesive surface to your encaustic painting. The heat gun is my tool of choice for fusing because it offers control and ease of use. Many options are available from art supply and hardware stores. I have a preference for the Wagner HT 1000. It is comfortable in the hand, cost effective and quite durable!

Alternative fusing tools are propane or butane torches, irons and tacking or encaustic irons. The torch offers a strong, concentrated flame, and a favorite among encaustic artists is the Iwatani. I find an iron or tacking iron offers less control because the heated surface of the iron is applied directly to the wax. Ultimately, it is about what is comfortable for you and your creative practice, and I encourage you to explore the many options available in this growing market.

SURFACES

Two things to know about surfaces when you are just beginning in encaustic: rigid and absorbent. The surface on which you paint in encaustic must be rigid; it cannot be flexible. Wax applied to a flexible surface, if not backed with a rigid surface, may crack. The surface also needs to be absorbent. The wax has to have something to grab hold of in order to establish a solid foundation on which to build with more wax and additional elements.

My favorite foundation for encaustic painting is Ampersand's Encausticbord. This surface is a luscious, luminous white, a result of the partnering of R&F Handmade Paints with Ampersand (R&F's encaustic gesso applied via Ampersand's surfacing process).

This board, developed and released after years of wanting for it in the encaustic world, is a welcome addition to the many surfaces available on which to paint. It is my go-to surface, not only for the rich absorbency and compatibility with encaustic, but also for the variety of sizes and options for cradling. Found in 1" (3cm) and 2" (5cm) cradles, Encausticbords offer a rich, contemporary look on which to create encaustic paintings.

Many unprimed wood art panels are readily available from art supply stores as well. And even a trip to the hardware store can offer the power-tool-savvy artist options in wood surfaces that can be cut and transformed into surfaces for encaustic work.

For bonus demos, art and more, visit artistsnetwork.com/encaustic-revelation.

BRUSHES

One rule: Go natural. Synthetic brushes will melt in hot wax. My favorites are hog bristle brushes in assorted sizes and hake brushes (also known as sumi painting brushes). Brushes ranging in size from 1"–3"(3cm–8cm) work well for all the techniques shown in this book.

OTHER TOOLS

I enjoy experimenting with anything I think could have an interesting effect on the wax. For incising—cutting design elements into the wax—I turn to pottery tools, awls, styluses, cookie cutters, putty knives and metal and wood filing tools. From the scrapbooking stores, I collect stamps, interesting stickers, embellishments and rub-ons. My favorite burnishing tool is a simple spoon, but bone folders and scissor handles work well, too. Other tools I have readily available for use in my encaustic studio are a metal ruler for straight-line incising, a small propane torch, assorted screens and stencils for incising and extension cords to allow for maximum reach with my heat gun.

MIXED MEDIA

Art supply and craft stores are great places to collect interesting collage papers, foils, leafing, oil paints, pastels, charcoals and photo transfer papers for use with the various encaustic techniques you will learn in this book. Likewise, scrapbooking stores offer a nice selection of rub-ons, papers, items to embed in your work and even unique incising tools.

I also scour hardware stores, fabric stores, salvage yards, thrift shops and garage sales for interesting materials to use in my encaustic work. Look for one-of-a-kind items to embed, from vintage buttons to rusty coils. You may even be surprised by the treasures found lingering in your junk drawer.

Leave no stone unturned in your search for innovative materials to use in your encaustic work. I can't begin to list them all, and I'm willing to bet that once you get started, you will find some I have yet to discover.

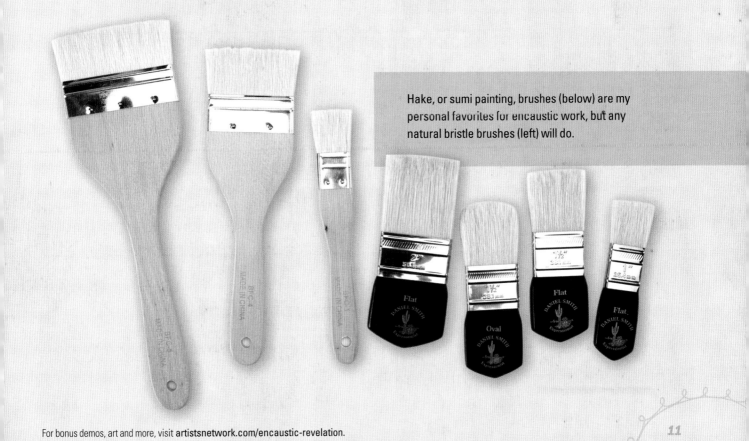

Hake, or sumi painting, brushes (below) are my personal favorites for encaustic work, but any natural bristle brushes (left) will do.

For bonus demos, art and more, visit artistsnetwork.com/encaustic-revelation.

11

creating colored wax

There are three main types of color you can add to wax for encaustic painting: pigmented medium, dry pigment additive and oil paint additive. All can be beautiful mediums for achieving colorful encaustic artwork.

PIGMENTED MEDIUM

This is my steadfast favorite option. Not only is it the easiest, neatest and safest, but the array of color options and consistency of color are an easy sell. These pre-made colors are sold through many encaustic manufacturers including Enkaustikos, R&F Handmade Paints, Evans Encaustic and several others. These pre-made paints tend to come in block sizes that fit nicely into the printmaker's tins, streamlining the process from solid to melted and ready to paint!

The advantage of these paints is that Enkaustikos and R&F not only source the best quality pigments the world over, but have grinders that mill these pigments to their finest consistency. This ensures the best dispersion of pigmentation through the melted wax, which, as the carrier for the pigment, is the most laborious to balance of any paint medium. Because of the superior milling in place, pigment suspension is exceptional from these manufacturers, and they produce the most consistent, rich and satisfying encaustic paints available. The artist has the opportunity to control the intensity of color through dilution by adding medium in desired proportions.

Assorted blocks of pre-made pigmented medium, pictured with a larger block of clear medium, add vibrant, consistent color to encaustic work.

DRY PIGMENT ADDITIVE

You can also make your own customized wax paints by adding dry pigments to medium. All caution in choosing this method though: Be sure to thoroughly read the manufacturer's safety warnings before you begin. This method should be used with caution because it involves working with loose particles that can be very dangerous to inhale. Also, getting a consistent color throughout a batch—or re-creating a color exactly as you created it before—can be difficult. I try to stay away from this technique because I favor the consistent hue and ease of use of the ready-made pigmented medium, but many artists find mixing their own encaustic paints to be highly satisfying.

For bonus demos, art and more, visit artistsnetwork.com/encaustic-revelation.

OIL PAINT ADDITIVE

A third choice for coloring wax is to add oil paints or oil paint sticks to the medium. This, too, can be effective and enjoyable if you like to create your own colors. I have found that oil paint sticks work better than traditional oil paints because the greater oil content in the traditional paints can dilute the medium, but you can use either successfully if you follow the steps below.

1

Squeeze oil paint onto a paper towel and let it sit overnight so the excess oil leaches from the pigment. This will allow the pigment to blend more easily into the medium.

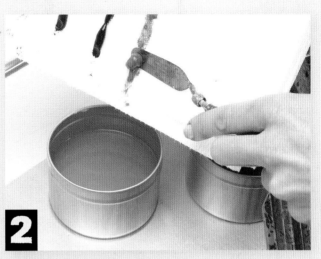

2

Add a bit of the paint directly to some hot wax medium. Experiment with the concentration, being conservative at first and gradually adding more, to achieve the desired color intensity.

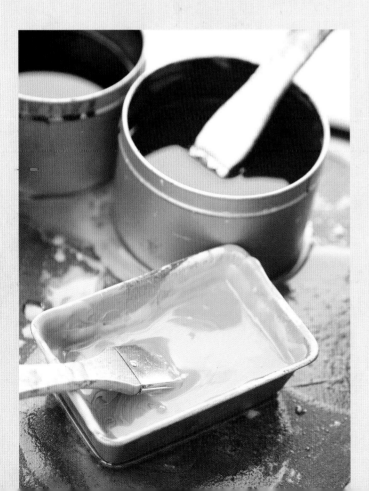

OPT FOR OIL STICKS

The oil content of pigment sticks is much less than that of traditional oil paints, so they can be added directly to the medium without the paper towel leaching process in step 1. Simply cut them directly into the hot wax medium. Here I am using an R&F Handmade Paints oil stick.

13

priming and fusing

Pick up your brush and begin! Grab your beeswax and come join me! Yes, it's that easy. Encaustic is just another paint medium, ready to be manipulated by the creative spirit within each person who has the dream to watch it flow.

SUPPLIES NEEDED

Encausticbord, art panel or hardware-store cut board

heat gun or fusing tool of choice

melted beeswax or medium

needle tool (optional)

paintbrush, hake recommended (2" [5cm])

1

Many of the projects in this book begin with a prime layer of medium. To accomplish this, warm the board with the heat gun. Hold the gun perpendicular to the surface, about 2" (5cm) away, and slowly sweep the heat back and forth across the board from top to bottom for about 30 seconds. The objective is to achieve a consistently warm-to-the-touch surface.

2

Using a large, flat brush, apply a sweep of wax across the board, covering the whole surface in this way until an even layer of wax exists.

HOT TIPS

- Keep the gun moving or you risk creating a hot spot that will resist the application of wax.

- Avoid overlapping strokes so that fusing will result in a smoother, more consistent layer.

- Returning the brush to the hot wax after each stroke will create a smoother application and help the brush move more easily because the wax remains warm and fluid.

- When the wax transforms from a dull matte finish to a shiny gloss, it has fused. It is not necessary to melt the wax completely to achieve a fuse; achieving this gloss is sufficient.

For bonus demos, art and more, visit artistsnetwork.com/encaustic-revelation.

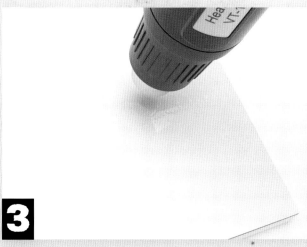

3

Using the heat gun, fuse this prime layer of wax by again sweeping the gun back and forth over the layer of wax in slow, even strokes.

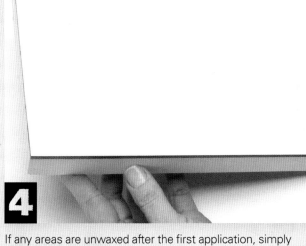

4

If any areas are unwaxed after the first application, simply apply additional wax to those areas and re-fuse them with the heat gun.

HOT TIP

This same technique of wax application may be continued with additional medium to build up a thick foundation, or you may begin applying pigmented encaustic paints at this point. After this base of priming has been established, any technique can begin. You are ready to try your hand at encaustic painting, collage and indulgent experimentation!

This prime layer is not mandatory to paint in encaustic. It is only a helpful suggestion so that when you begin in color, your more expensive, pigmented paints do not disappear into the board because of the sheer absorbency of the unprimed surface. Many of the techniques in this book begin with foundations on the surface before any wax is used. Therefore, this priming technique is put into play after these foundations have been established.

5

If you see any stray hairs or particles in the wax, gently pick them out with a needle tool. Reheat to smooth the disturbed wax.

HOT TIP

Take caution with the heat gun and any heated tool for that matter. I recommend reading the manufacturer's precautions, but in this case I add a special aside. If you are like me and get excitedly wrapped up in the creations you are producing, it is all too easy to become distracted by the process and (gasp!) forget to pay mindful attention to your heat gun. It burns! I try to always keep my gun upright, perched on its tail end, so the extremely hot tip will not set my work surface alight. In this position I have been known to reach across said tip and give myself a nice brand on my forearm though. A solution?! Find a hair dryer holder, or a holder of this sort specifically designed for your heat gun, and install it in your studio to always have your heat gun properly secured.

For bonus demos, art and more, visit artistsnetwork.com/encaustic-revelation.

15

Amanda Jolley

encaustic encapsulation: creating jewelry with encaustics

A tale of a messy spill turned glorious: I was just wrapping up a lovely day of encaustic painting in the studio. I put away my tools, turned off my griddle and reached up to shut the ventilation window. Ack! My arm knocked the paintbrush in the tin of green encaustic paint. Wax flew from the tin, splashing all over my work area. The majority of beeswax landed on a remnant of wax paper. After allowing it to cool, I peeled the thin sheet of green wax off the paper. With a thin piece of wax in my hand, I was hit with the idea: soldered jewelry encasing encaustic paint! A journaling excerpt from that day of inspiration says it all. "My heart is pounding: excitement, adrenaline, pure inspiration, perhaps too much espresso." And a new jewelry line was born.

SUPPLIES NEEDED

black patina (optional)

copper tape, black-backed, or black-backed copper foil, ⅜" (10mm)

Diamond Glaze or an invisible-drying glue that will adhere to glass (optional)

encaustic paint or pigmented beeswax in your color choice

fid or bone folder for burnishing flat- and bent-nose pliers flux brush

gel or paste flux

glass cleaner

heat-safe work surface for solder-ing such as a large ceramic tile or a cookie sheet

jump rings

knife or ulu

metal polish

necklace chain or earring hooks

old hand towel

paper towels

ruler

sal ammoniac

seed beads (optional)

small tabletop vise (optional but quite helpful)

solder, lead-free

soldering iron with ⅛"–¼" (3mm–6mm) tip, 100w with internal tem-perature control (preferred) or lower

wattage soldering iron used with a rheostat

sponge

sturdy stand for soldering iron (optional)

tin for melting the wax

two pieces of same sized glass for the pendant (Note: microscope slides and other thin glass pieces are too thin for this project. Use clear window glass or precut glass that is at least ¹⁄₁₆" [2mm] thick.)

wax paper

"Vulnerability is the birthplace of innovation, creativity and change."

— Brené Brown

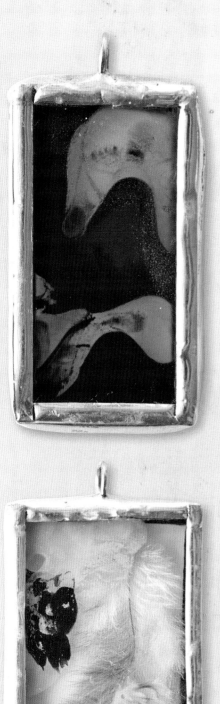

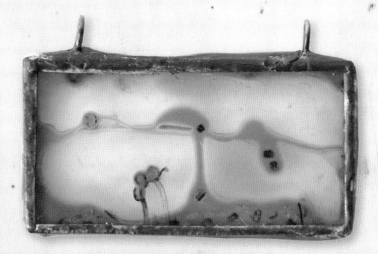

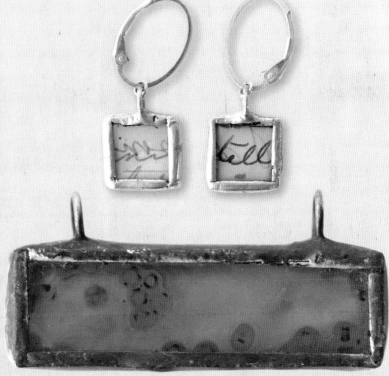

Have fun experimenting with additions to the wax sandwich! Clockwise from top left, materials include:

various colors of encaustic paint

vintage seed beads and encaustic paint with black patina

encaustic medium and 1940s college notes

vintage seed beads and encaustic paint with black patina

flyfishing feather and encaustic paint

For bonus demos, art and more, visit artistsnetwork.com/encaustic-revelation.

17

MAKING A WAX SANDWICH

Making a uniform wax sandwich is key in producing a finished pendant with straight edges. When layering the sandwich, be sure the wax pieces are about the same thickness. When you hold the sandwich between your fingers, the space between the glass pieces should be uniform all around the edges. This will allow you to apply the copper tape evenly.

1

Clean the glass pieces with glass cleaner and a paper towel.

2

Heat your knife or ulu and chop a few shards of encaustic paint in whatever colors you like. The pieces should be smooth and thin and should easily fit between two pieces of glass.

3

Arrange the wax pieces in a pleasing composition on one of the glass pieces.

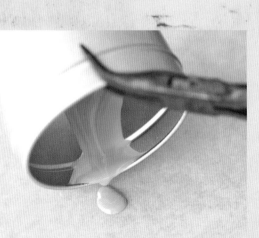

HOT TIP

Alternately, you can melt a bit of encaustic paint in the color of your choice in a pan or tin. (Keep the temperature of the wax under a safe 200°F [93°C].) Pour a thin layer of the melted wax onto a sheet of wax paper and allow the paint to cool completely. Then simply break off pieces of the wax that will fit in between the two pieces of glass. Again, thin, smooth pieces are best.

For bonus demos, art and more, visit artistsnetwork.com/encaustic-revelation.

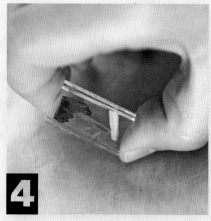

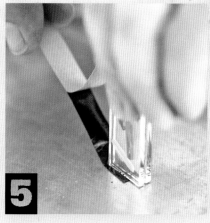

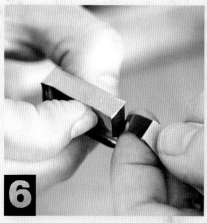

4 Place the second piece of glass on top of the wax to make a sandwich. The wax does not need to fill the glass because it will melt during the soldering process. It just needs to fit within the glass sandwich with no overhang. Hold the sandwich secure between the thumb and index finger.

5 Cut a piece of copper tape slightly larger than the perimeter of the glass or work directly off the roll.

Apply the copper tape beginning near a top corner of the pendant and keeping the glass as centered as possible.

6 Walk the glass around the copper tape, centering as you go. You should have a small overlap of tape, about ⅛"–¼" (3mm–6mm), when coming full circle.

HOT TIP
I have found it best not to remove the adhesive backing of the copper tape all at once, but rather just a bit at a time. Otherwise, it sticks to everything, including itself.

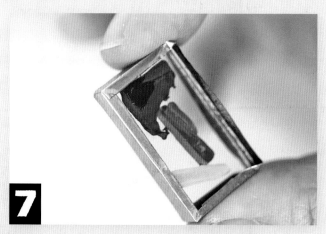

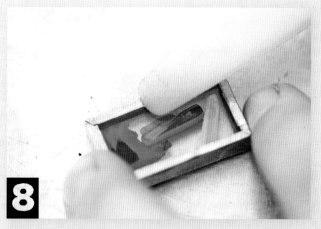

7 Fold the top edge of the copper tape onto the glass. Tuck and fold the corners.

Fold the next edge of copper tape onto the glass and tuck the corners. Continue around the glass until all the copper tape on both sides of the sandwich has been folded onto the glass.

8 Burnish well, pressing the tape securely onto the glass with a fid or bone folder, sealing the edges as much as possible. A poorly burnished edge will release from the glass when introduced to the heat, so go over the whole sandwich a second time.

SOLDERING

Preparation and setup are important for safety and efficiency in soldering. Arrange your tools and materials in your soldering work space (like a tile or cookie sheet). You will want to have your solder (with about 3" [8cm] extending from the roll), flux and flux brush at the ready. Place a towel in your lap. Have a damp sponge nearby for cleaning the iron tip.

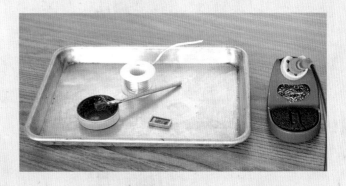

While holding the pendant securely in your nondominant hand with parallel flat-nose pliers, use your dominant hand to brush flux onto the copper tape.

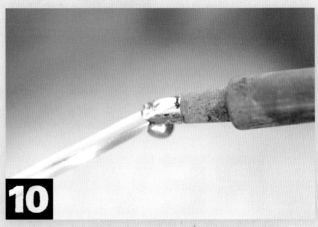

Pick up the soldering iron with your dominant hand and touch the iron to the top of the solder, getting a dab of solder on the tip of the iron by allowing it to melt onto the iron. Work from the top with a downward motion. The solder will hold onto the bottom of the iron tip.

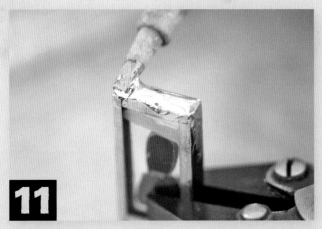

With the pendant perpendicular to the ground, gently touch the tip of the soldering iron to the copper tape and move it across the copper tape, allowing the solder to flow naturally. Wait for the solder to set before moving to the next side.

HOT TIPS

- Wait, wait, wait before moving the charm to solder additional sides. Allow the solder to set. (Count to five. Or even ten.)

- A few layers of solder may be added in the same manner if you prefer a thicker edge.

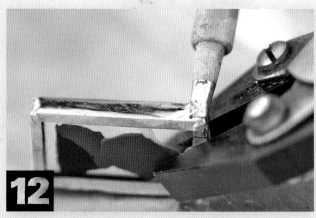

12

Turn the pendant to the next side using your pliers. Do not touch the glass with your hand.

Repeat steps 9–12 around the pendant.

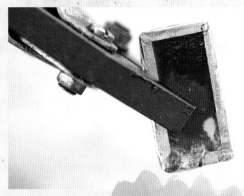

HOT TIP

By the third side, you may experience some wax seeping out of the edge. That is normal and will be cleaned off at the end.

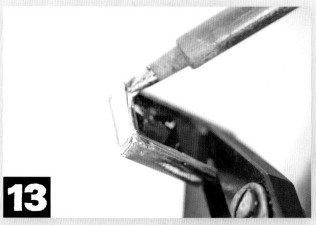

13

Tilt the pendant 45° and solder the foil edge that lies on the glass with the soldering iron. Have your iron tip just on the edge of the copper tape so as not to cause a ripple in the side you have just completed. Wait for the solder to set before moving to the next side.

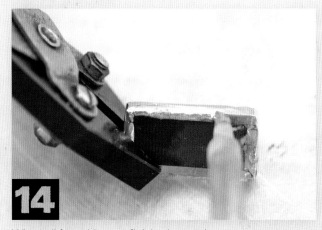

14

When all four sides are finished, start the same process on the back edges, again holding the pendant at 45°.

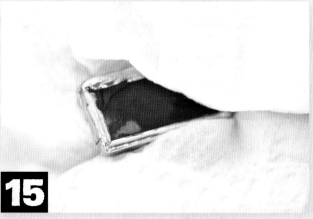

15

When the soldering is complete, rub off any excess flux and wax with a paper towel. But beware: The glass is still very hot at this point. Do not touch it directly. Set the pendant aside to cool, and again, use a towel and pliers, not your fingers, to prevent burns.

For bonus demos, art and more, visit artistsnetwork.com/encaustic-revelation.

ADDING JUMP RINGS

Prepare to add jump rings to your soldered pendant by arranging your tools and materials for both safety and efficiency. You will want to have about 3" (8cm) extending from the roll, flux, flux brush, pliers and jumps rings at the ready, and soldering iron in place.

16

Securely prop the pendant upright. My favorite tool for this is a tabletop vise. Other options include securing between small bench blocks or using a clamp on each side of the pendant near the bottom so as to anchor the pendant securely to the work space.

Using a pencil, mark on the pendant where the jump ring(s) will be attached. Use a ruler if you'd like.

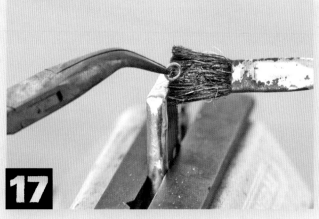

17

Consider in which direction the jump ring(s) will need to be attached to accommodate a chain or choker.

Apply flux to both the pendant and jump ring, holding the jump ring with needle-nose or bent-nose pliers in your nondominant hand.

18

Dab a small bit of solder on the tip of the iron.

19

Tap the iron lightly on the work surface so the solder falls to the corner point of the iron tip.

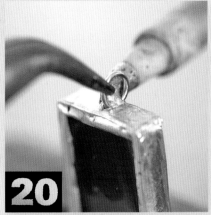

20

With the jump ring held in place on the pendant, touch the iron right behind the jump ring.

Holding everything steady, allow the solder to flow for a moment.

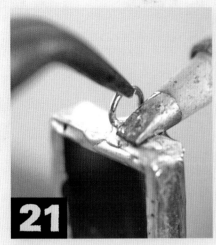

21 After the solder flows, keep holding the jump ring with the pliers while moving the iron to the sides and front of the jump ring.

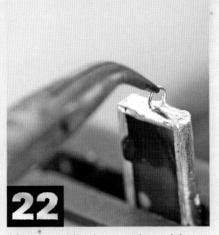

22 After the solder changes sheen, it is safe to release the pliers' hold.

23 If you aren't satisfied with your final piece, you can reheat and melt the wax with a heat gun.

FINISHING

1 Clean the pendant with metal polish.

2 Buff it with a soft towel.

3 Spray glass cleaner on a paper towel and polish the glass with the paper towel. Do not spray cleaner directly on the pendant.

4 Attach a chain or earring hooks and enjoy!

SOLDERING IRON CARE

- Keep a very damp sponge handy to clean the tip of your soldering iron throughout your work. Clean the tip often while soldering. I wipe mine on the sponge after each application of solder.

- If the iron is not behaving, it may need a thorough cleaning with sal ammoniac. Dig a hole in the sal ammoniac brick, leaving the powder debris. Dip the tip, with solder, in the powdered sal ammoniac. Quickly wipe the tip on a wet sponge.

- WARNING: Do not stand over the fumes. Seriously, don't do it. It's not healthy.

- Keep a bit of solder on the tip of the iron as you finish your soldering, and allow the iron to cool with the solder on the tip.

- Always unplug the soldering iron when you are finished.

For bonus demos, art and more, visit **artistsnetwork.com/encaustic-revelation**.

23

ADDITIONAL TIPS AND IDEAS

- Experiment with adding more than just wax to the sandwich. I have found tiny seed beads to be a fun addition that also add stability to my sandwich. Glue a bead in each corner of the glass with a tiny bit of Diamond Glaze and allow the glaze to dry. When you add bits of wax to the sandwich, add more seed beads (unglued). As the wax melts during soldering, the beads float under the glass. The result is a random pattern of wax and beads that is quite playful. What else could you add? Try thread, bits of paper, tiny feathers, bits of shells and anything else that strikes your fancy.

- If you prefer a more tarnished or darker look, add a black patina to the solder after the pendant is finished. Rub a bit of patina on with a cotton swab, and then rub off the excess patina with a towel. The longer you leave the patina on before rubbing, the darker the metal will be.

- Add a couple different colors of encaustic paint and see how they blend. Sometimes they blend completely, creating a new color. Sometimes the colors blend in spots but leave nice hints of the original hues. (Be sure to refer to a color wheel so as not to make mud.)

- If you have not used a soldering iron before, try creating a paper sandwich rather than a wax sandwich for your first try. Make a tiny collage or shrink a copy of your own artwork to print and encase between the two pieces of glass. Then follow the remaining instructions. This will give you a better feel for how the solder flows before you have to deal with adding a dimensional object to your sandwich.

- Add natural beeswax or encaustic medium to your encaustic paint when melting to soften the intensity of the color. The more beeswax you add, the softer the color will be.

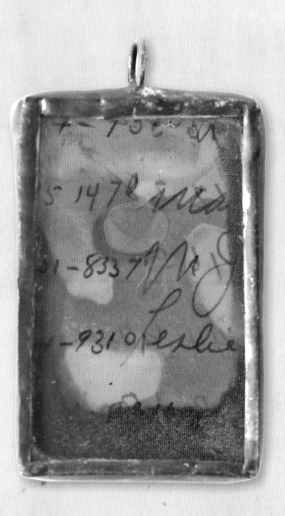

RESOURCES

Enkaustikos
encausticpaints.com | encaustic paint

R&F Handmade Paints
rfpaints.com | encaustic paint

Swans Candles
swanscandles.com | natural beeswax

Glass Crafters Stained Glass Supplies
glasscrafters.biz | soldering iron, copper tape, solder, flux, patina

All-Spec Industries
all-spec.com | soldering irons: Weller W100P (Be sure to order the ¼" [6mm] tip as well: CT6E7.)

Rings & Things
rings-things.com | chokers, jump rings, bulk chain, clasps

Have fun experimenting with additions to the wax sandwich! Left, materials include:
vintage farm journal and encaustic paint with black patina

Right, clockwise from top left, materials include:
vintage farm journal, mulberry paper and encaustic paint with black patina

paper hole punches and encaustic paint with black patina

twine and metallic encaustic paint with black patina

thread, vintage seed beads and encaustic paint

For bonus demos, art and more, visit artistsnetwork.com/encaustic-revelation.

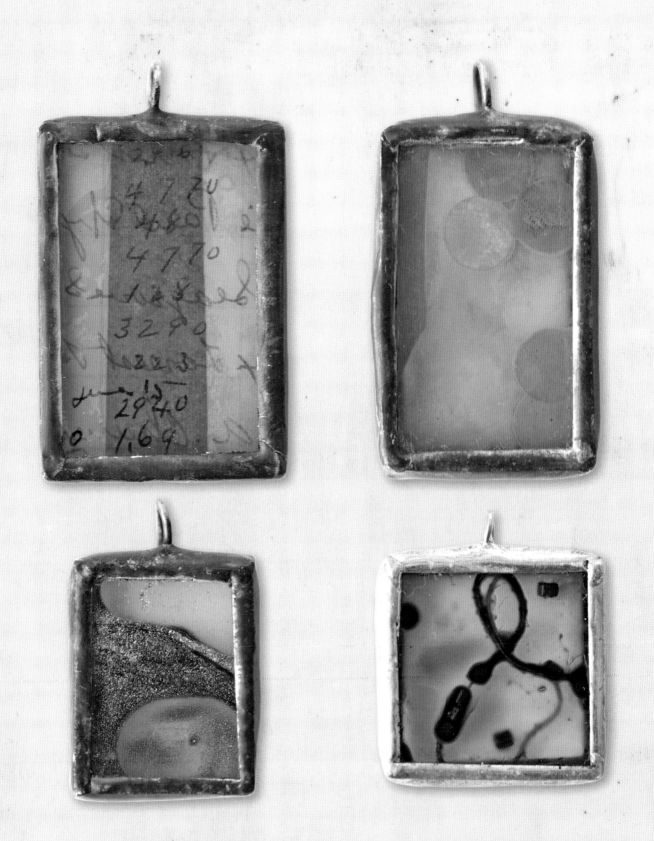

"Whatever it is, surely art involves creativity and originality. Whatever form art takes, it gives outward expression to what otherwise would remain locked in the mind, unshared."

—Edith Schaeffer

For bonus demos, art and more, visit artistsnetwork.com/encaustic-revelation.

25

Bridgette Guerzon Mills

plaster and encaustic books

Book art for me is just such an intriguing way to work. I am able to think about structure along with concept. I can create a piece that people can physically interact with. It becomes something intimate, rather than distancing, as some art can be. As someone who binds her own journals and makes books in addition to painting, I was always intrigued by how I could bring encaustic into my journal and bookmaking practice. When I learned about plaster gauze, alarm bells went off in my head, and I realized that this was the material that could bridge my two worlds—encaustic painting and bookmaking.

Plaster creates such a wonderful base for encaustic. And when it comes to making books, it provides a nice mix of rigidity for the encaustic to hold onto with some flexibility, which works well for pages of a book. The plaster is also very absorbent and holds the wax well. And then, of course, there is the texture. Oh, the texture! The wax fills into the crevices created by the plaster and in so doing provides a way to create beautiful, organic pieces.

SUPPLIES NEEDED

3 pieces of cloth, 3" × 5" (8cm × 13cm) (I used cotton muslin)

bucket of water

Burnt Umber and Yellow Ochre oil paint

encaustic medium

heat gun

inkjet prints on lightweight paper (office computer paper is fine)

latex gloves

lint-free cloth or paper towel

paintbrushes

photocopy

ribbon

Rigid Wrap Plaster Cloth, 4" (10 cm) wide

scissors

sewing needle

single-edge razor blade

spoon

Titanium White encaustic paint

twigs, leaves, bark, etc.

vegetable oil

wax paper

waxed linen thread

1 Cut a piece of plaster cloth to 4" × 5" (10cm × 13cm). Dip the plaster cloth into a bucket of water to wet it.

2 Using your fingers, smooth out the plaster surface. Lay the wet plaster cloth on wax paper to dry while you make the other plaster pages. Make eight of these plaster pages in order to make a four-page accordion book.

3 After you have your pages laid out, you can join them. This is best to do while the plaster is still wet. Lay two plaster pages next to each other, about ¾" (19mm) apart. Place your 3" × 5" (8cm × 13cm) piece of fabric between the two plaster pages, with the fabric overlapping the plaster pages by ¼" (6mm).

4 Lay another of your prepared plaster pages on top of the first page, sandwiching the fabric between the two plaster pieces.

5 Smooth out the plaster layers with your fingers, being sure that there is a good adhesion between the two layers of plaster gauze.

6 Take another prepared plaster page and lay it to the right of the plaster page you just worked on, with ¾" (19mm) of space between.

For bonus demos, art and more, visit artistsnetwork.com/encaustic-revelation.

7

Place the 3" × 5" (8cm × 13cm) piece of fabric between the two, overlapping by ¼" (6mm).

8

Repeat steps 4–6 to the right of the plaster pages you just worked on until you have four pages laid out in front of you with fabric in between.

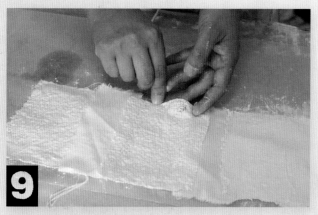

9

Place the last two prepared plaster pieces on top of the two pages you just added, sandwiching the fabric between the plaster pages.

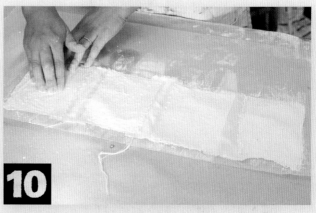

10

Wet the plaster surface with wet fingers, and smooth out the layers, ensuring they adhere to each other.

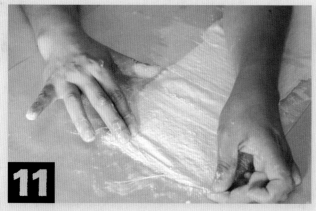

11

Lay your book out to dry. Take time to shape the edges of your pages. How you leave the plaster to dry will be its final form. Drying times take anywhere from a few hours to overnight.

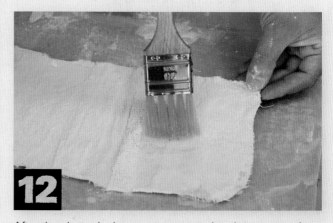

12

After the plaster is dry, you can start to brush on encaustic medium. Be sure to wipe the excess wax off your brush before you lay it on the plaster. You want an even coverage of wax on your surface, but keep it light. Too much wax on a piece that will be handled, such as a book, may cause the wax to crack.

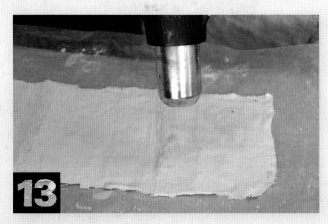

13

Fuse between layers.

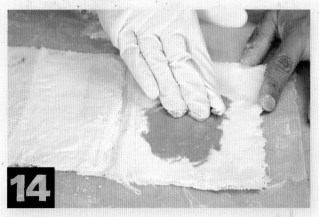

14

The next step is to bring out the natural texture created by the plaster and encaustic surface. Put on a protective latex glove and smear a bit of Yellow Ochre oil paint onto your pages.

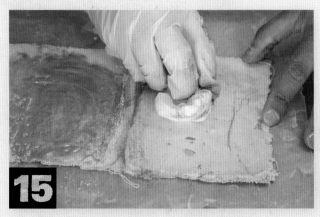

15

Using a clean, lint-free cloth or paper towel, rub the paint into the surface. You want to accomplish two things: rubbing the oil paint into the uneven surface to bring out the texture and rubbing away all excess oil paint from the smooth surface. Dab vegetable oil to the surface to help wipe away the excess oil paint.

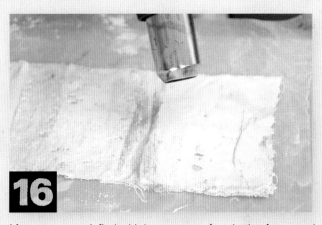

16

After you are satisfied with how your surface looks, fuse gently.

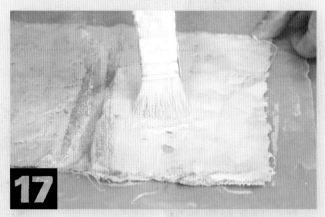

17

Brush on a layer of Titanium White encaustic paint that has been thinned with medium so it is fairly transparent.

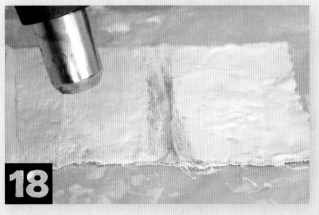

18

Fuse. Move your heat gun slowly and notice how the oil paint and encaustic paint in the prior layer peek through this layer.

For bonus demos, art and more, visit artistsnetwork.com/encaustic-revelation.

29

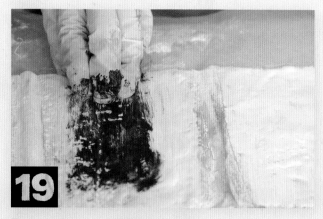

19 Repeat the process with oil paint, using the Ochre or try another color like Burnt Umber.

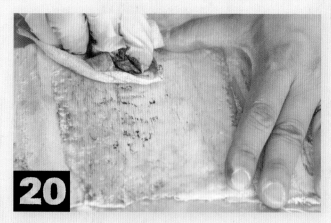

20 Again, wipe away excess oil paint using vegetable oil and a paper towel.

21 Fuse lightly.

22 Repeat steps 12–21 on the back side of the plaster pages.

23 At this point you can embed images onto the surface by dipping an inkjet print printed on light paper in wax.

24 Adhere the print to the page with medium.

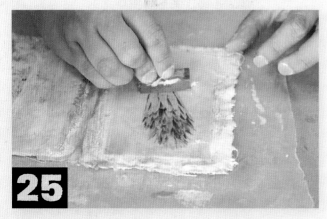

25

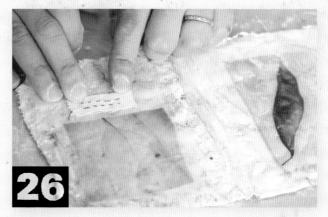

26

Holding a razor blade at an angle, drag the blade across the surface of your image to remove excess wax as well as eliminate any air bubbles between the paper and the waxed plaster page.

You can also press light objects into the wax. The wax should be warm to ensure adhesion.

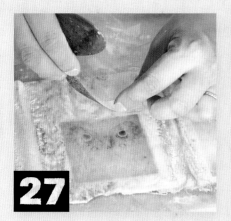

27

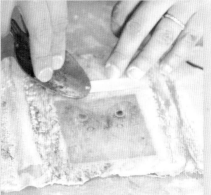

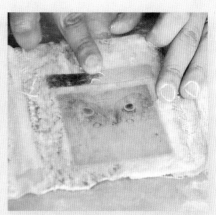

If you have a fairly smooth surface, you can try a photocopy transfer. Place the photocopy face down. Burnish with the back of a spoon. Wet the paper with water, and then rub the pulp away with your fingers. Fuse lightly.

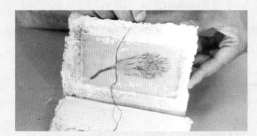

HOT TIPS

- The plaster surface is malleable enough that you can pierce the plaster and encaustic with a sewing needle. You can sew objects onto the pages, which adds a nice design element and can also stabilize the object.

- Instead of attaching the pages all at the same time with the fabric strips, dry separate pages overnight. Create your pages following the same instructions, using encaustic medium, encaustic paint, and oil paints. Using a needle and waxed linen thread, attach the pages to a long ribbon and hang like a prayer flag.

RESOURCES

Hollander's
hollanders.com | bookbinding supplies
(I like to use waxed linen thread with bookbinding needles when I am sewing into the encaustic and plaster pages. You can buy the spools and needles in the bookbinding sections of art supply stores.)

Dick Blick
dickblick.com | plaster
(Try Dick Blick Plaster Cloth or Activa Rigid Wrap Plaster Cloth.)

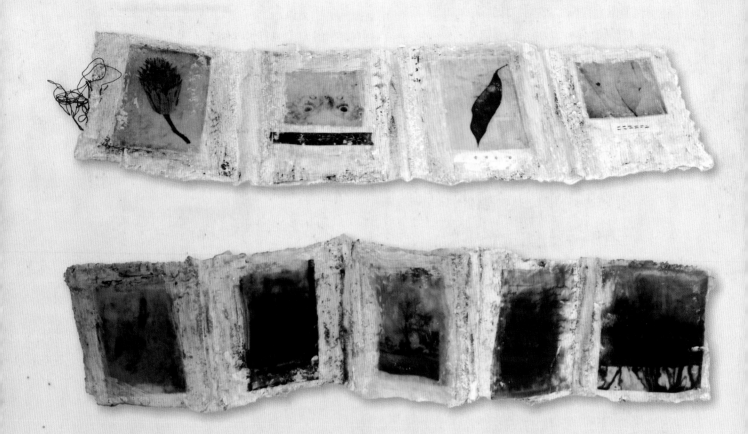

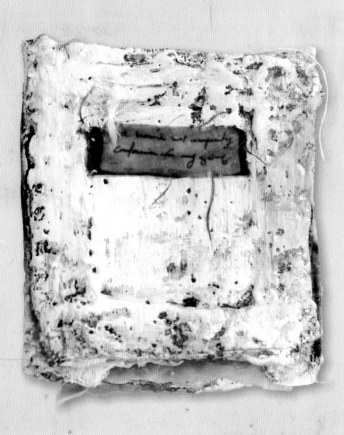

A Closer Look

top image | This book is an exploration of the small details in life that are often overlooked as well as hidden. Before I printed out the images that I used, I altered them using filters on my phone.

(artist book, inkjet prints, seeds, sewn fabric, photocopy transfer)

Container for My Grief

middle and bottom images | Due to a severe storm that resulted in extensive flooding of my studio, much of my work was destroyed. Some of the damage that occurred in my many personal journals was hauntingly beautiful. What else could I do but make art from them? I made a plaster and encaustic book to contain these images.

(artist book, inkjet prints of scanned images of water damaged journals)

For bonus demos, art and more, visit artistsnetwork.com/encaustic-revelation.

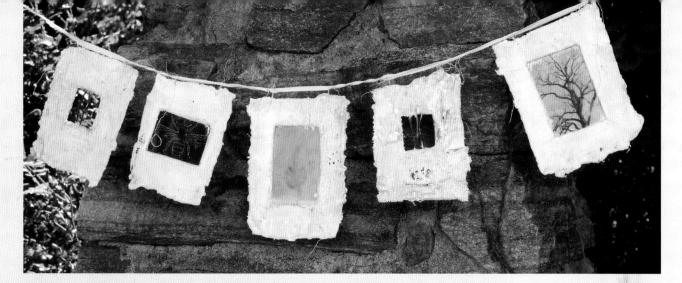

"Painting is a journey. It is the way I mark my path through life."

—Virginia Cobb

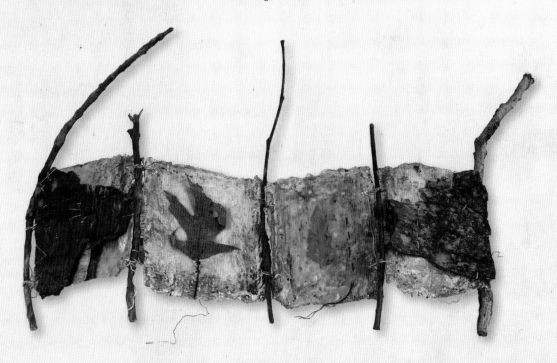

Meditations

top image | I created this book while listening to interviews and stories on the radio when the tsunami hit Japan. Each page became prayers for the lives that were lost and for the general health of our planet. Whether a tree, bee or human, we are all connected.

(prayer flag artist book, twigs, inkjet prints, pressed fern, lokta paper)

Walking the Earth

bottom image | This earthy book contains my gatherings from walks in the woods. I had first thought that I could embed my items into the warm wax surface. However, I decided to use waxed linen thread to sew the items onto the encaustic plaster pages for added security. I like the texture and the design element that the stitches added to the overall feel of the book.

(artist book, twigs, bark, leaf, pressed fern)

For bonus demos, art and more, visit artistsnetwork.com/encaustic-revelation.

33

Crystal Neubauer

boxing encaustic: intuitive collage and assemblage combinations

Over the years of working as an artist, I have dabbled and experimented in many different mediums. From assemblage to jewelry making, digital media, acrylic painting, oils and encaustics, I seem to have tried it all. But no matter where my creative pursuits and interests take me, I always seem to find my way back to my first love: collage. There is something about the gathering of these bits and scraps and pieces that have been long forgotten or deemed to be trash, unworthy of a second glance, that pulls and connects with my heart, and I have to carry them home. And while the art of collage can be governed by rules and artistic theories and long standing tried-and-true techniques, my process is largely one of intuition and learning to "hear" as the pieces begin to speak to me.

As my work has evolved through the many seasons of my artistic journey, I begin to see the deeper meaning and reason for this passionate pursuit, this love affair of mine. It is the story of redemption, of seeing something dirty and making it into something beautiful. I love to see the connections my students make as I share with them this intuitive process and encourage them to begin to listen to the voice that is their own. There is redemptive value in sharing our stories, and the art of collage and assemblage is a powerful tool for telling them.

THE INTUITIVE GATHERER

If you are like most artists, you already have a stash of papers and items that have been gathering dust in your studio, but you can't bear the thought of getting rid of them and you can't explain why. This is the best place for you to start pulling together your materials for these projects. Don't think about it too deeply. Don't try to make sense of why you are gathering what you are gathering or try to find the story or meaning behind it. Just look around and gather what you feel attracted to. Get a basket or shoe box of some kind and start tossing in anything that catches your attention. Pick up those shells you brought home from the beach, the broken china you thought you would glue back together someday and the stash of handmade papers you bought on a whim. Gather whatever it is that strikes your fancy at this moment in time. Next, head to the junk drawer in the kitchen, the box of cast-offs in the attic or the storage container under the bed, or if you prefer, make an artist's date out of it and head to your local flea market. Seek out old books that are falling apart, lovely hardware, broken rosaries or a clock that no longer keeps time. Small items will work best for this project, but again, don't overthink it. There is a reason you are attracted to the things that catch your eye. But you don't have to plan. No worries! We are working solely on intuition.

For bonus demos, art and more, visit artistsnetwork.com/encaustic-revelation.

WORKING WITHIN THE BOX

The art of assemblage has been around for nearly a century, established as a legitimate form of artistic expression by the likes of Joseph Cornell and Robert Rauschenberg. What many words may fail to speak, a picture can paint in an instant. How much more so when that picture is a gathering of items with personal meaning that impact the soul.

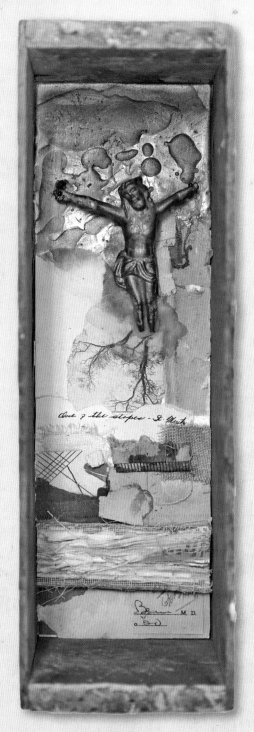

No Greater Love
(mixed-media collage)

SUPPLIES NEEDED

baby wipes

bristle brush

cold-pressed watercolor paper (140-lb. [300gsm])

encaustic medium (clear and any colors you desire)

Golden Acrylic Glazing Liquid (satin finish) or gel medium (in place of paste and glazing liquid)

hand drill

items from your intuitive-gathering spree

Jacquard Pearl Ex pigments and color duster brush

long-handled tweezers

paintbrush

paper cutter

razor blade

scissors

small found object

small wooden box (I suggest an old cigar or cheese box, but if you don't have access to something like this, look for a small, unfinished wood box at your local craft store)

thin wire

Yes! Paste

For bonus demos, art and more, visit artistsnetwork.com/encaustic-revelation.

35

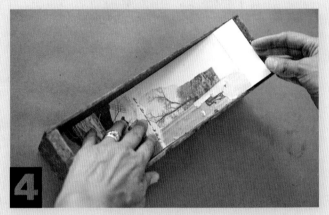

1 Begin by cutting a piece of 140-lb. (300gsm) cold-press watercolor paper to fit the interior of the box. You will cover this paper with collage, so do not glue it into the box yet.

2 The art of working intuitively is not as mysterious as it sounds; it is simply a matter of trusting your instincts and practicing. Sort through your scraps and begin to lay out a design to fit the trimmed watercolor paper, rearranging and moving things about until the design pleases your eye. Stick to your papers at this point and save the embellishments for later in the process.

3 After you have a design that pleases you, glue it to the watercolor paper using the glue of your choice. My favorite is a combination of Yes! Paste and Golden Acrylic Glazing Liquid with satin sheen. A mix of about 3 parts paste to 1 part glazing liquid gives me the brushing ease I appreciate with the longer working time I need. Stir the two until the mixture looks like banana baby food and then brush it onto each scrap and glue down. Lightly wipe any excess glue off the surface of your collage with a baby wipe. Encaustic medium will not stick to a gel medium, especially one that is glossy.

4 After the collage is glued to the watercolor paper, brush the back of the paper with glue and insert it into the box. You may want to put some type of weight on top of the paper as it dries in the box to ensure that it is pressed flat and adheres well.

For bonus demos, art and more, visit artistsnetwork.com/encaustic-revelation.

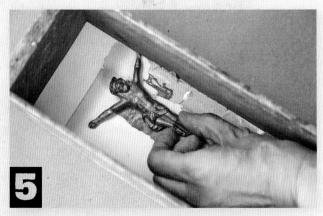

5

After the collage is dry, arrange your embellishments or heavier items in the box and determine if you will attach them before or after the encaustic process. My piece will be attached as the last step, so I have removed it and set it aside for now.

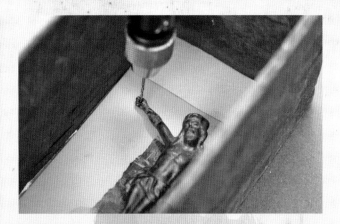

HOT TIP
If you think you will fasten your object in the box with wire (for added support, for example), drill holes now.

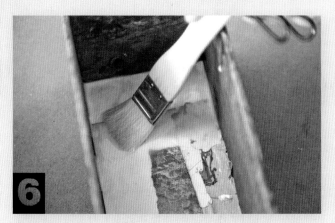

6

Working with clear encaustic medium, build up layers in the area you have determined will work with your composition, fusing between layers.

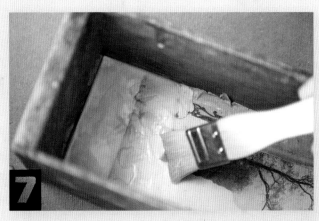

7

Create texture and ripples with your brush and heat gun. Use your intuitive discretion at this point as well; you may want to cover the entire collage with wax or just a portion.

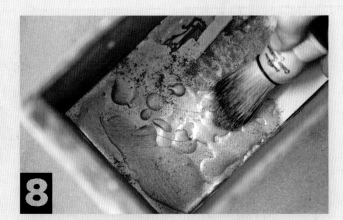

8

After the encaustic is dry, apply Pearl Ex pigment to enhance the effect and create sheen. Or you may choose to add a pigmented encaustic color, PanPastels, or nothing at all.

For bonus demos, art and more, visit artistsnetwork.com/encaustic-revelation.

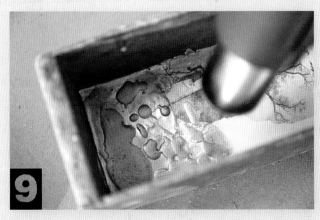

9

Fuse quickly and lightly to set the pigment .

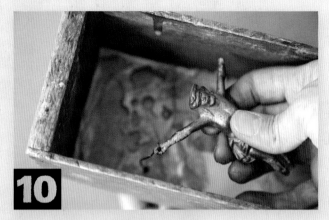

10

Set the embellishment in place. Here I'm using wire to permanently secure a heavier-than-usual embellishment. Run the wire through the holes you drilled in both the embellishment and the box. The ends of the wires should exit through the back of the box.

11

Tie or wrap the wire ends together to secure.

12

You can also secure your embellishment (or part of it) in place by using encaustic medium as a glue.

13

If you have added too much encaustic medium, scrape some back using a razor blade.

HOT TIP

As you work, do not question whether your design is right or wrong, or whether there is any discernible meaning to be found. Just trust what pleases your eye and leave it at that. One common mistake is thinking the story has to be obvious and spelled out for the viewer to understand it. Most often I have a growing sense of what my work is saying as it develops, but many times it is not until I have stepped back and viewed the completed piece that it hits me. This, too, is an intuitive process. There is a place deep in the spirit that will recognize the truth when it comes to you.

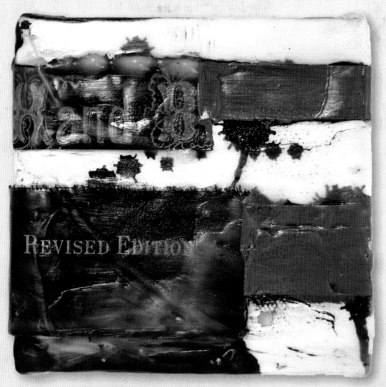

New and Improved
(mixed-media collage)

CONSIDERING ALL THE ANGLES

A small canvas can pack a big punch when all sides are utilized as part of the design. This turns what would be a tiny plain picture into a 3-D work of art with sculptural qualities. Consider all angles of the canvas, and add depth and mystery by working under the wax, between the layers and on top of it.

SUPPLIES NEEDED

burnishing tool or craft stick

chalks

charcoal or graphite stick

cheesecloth or textured paper or fabric of your choice

Chinese ink brushes

clear encaustic medium

coconut oil

India ink

items from your intuitive-gathering spree

loaf pan

long-handled tweezers

oil sticks

painter's tape

razor blade or ceramic loop

*small stretched canvas (I am using a 4" × 4"
[10cm × 10cm] canvas with a 1⅜" [3cm] profile)*

For bonus demos, art and more, visit artistsnetwork.com/encaustic-revelation.

39

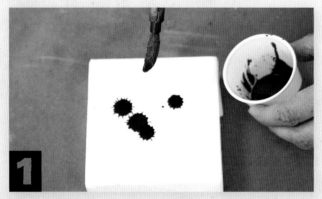

1

Start your design by dropping India ink onto the canvas. Let your eye and arm be your guide as you load up your brush and hold it over the canvas to drip. Do not attempt to exercise too much control.

Alternatively, you may choose to work with oil pastels, chalks or oil paints directly on the canvas. Experiment with a small section or cover the entire canvas—don't forget the sides!

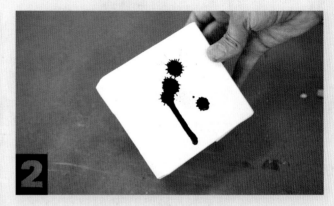

2

Tilt the canvas, encouraging the ink to move and spread.

3

Melt enough encaustic medium in a loaf pan on your skillet to have a good 3"–4" (8cm–10cm) of liquid. Place the canvas face down in the pan and, using your long tweezers, push the canvas into the encaustic until all sides have been submerged.

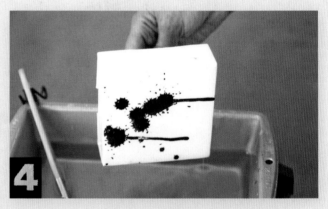

4

Using the tweezers, remove the canvas from the wax, holding it over the pan until it is no longer dripping.

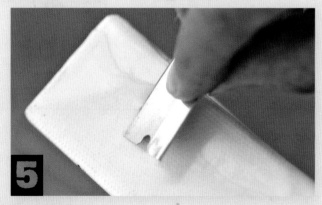

5

If you desire, smooth any drips and imperfections in the surface with a razor blade or ceramic loop.

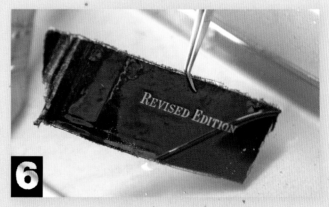

6

Next, choose a scrap from your stash and, using the tweezers, give it a dunk in the wax.

For bonus demos, art and more, visit artistsnetwork.com/encaustic-revelation.

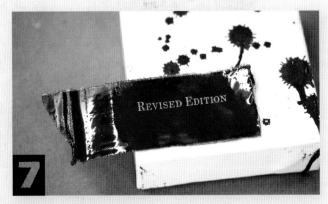

7 Set the scrap in place on top of the canvas, trusting the placement to your intuitive eye and allowing some of the background design to show.

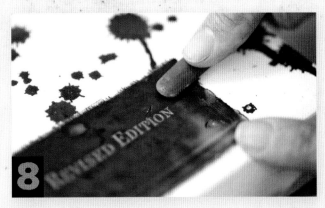

8 Gently rub with your finger or a wooden craft stick.

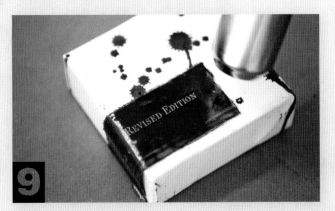

9 Lightly fuse the entire piece to set.

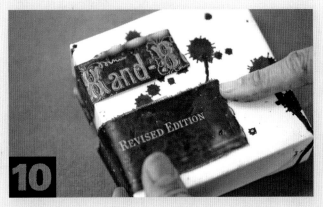

10 Repeat this process until you have completed your collage design.

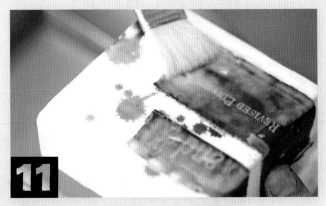

11 Completely cover the entire canvas (including the sides) with a final clear coat of encaustic wax and fuse. Let the wax cool.

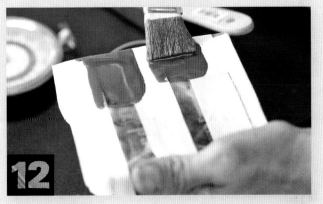

12 Choose a section of the canvas (top and sides) and mask with painter's tape. Apply pigmented colored wax between the masking.

HOT TIP

Make sure the tape adheres to the cooled wax by burnishing the edges well. If it doesn't, wax may bleed under the tape. If colored wax does bleed under the tape, you can use a razor blade to remove it.

For bonus demos, art and more, visit artistsnetwork.com/encaustic-revelation.

41

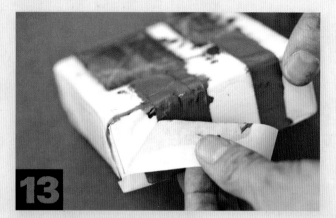

13 Remove the tape and fuse the wax.

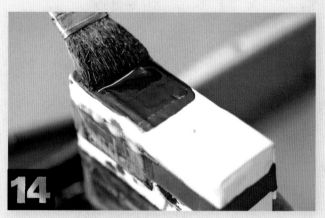

14 Add additional paint as desired and fuse.

15 Using a piece of crumpled cheesecloth (or textured item of your choosing), quickly press into the warm colored wax and remove.

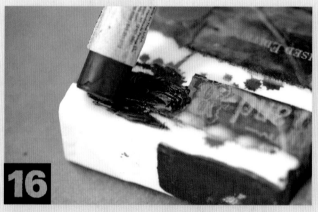

16 When the wax has cooled completely, enhance and draw out the texture of the surface with a pigment stick, charcoal, graphite stick or chalks. (In this photo I am using a pigment stick.)

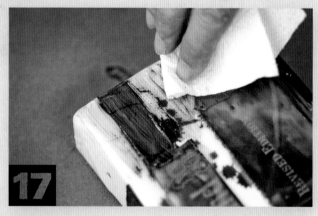

17 Wipe off any excess pigment stick, charcoal, graphite stick or chalk with a paper towel soaked with coconut oil. The coconut oil removes the excess but also blends. Fuse one final time and cool completely.

RESOURCES

Enkaustikos
encausticpaints.com | encaustic medium and pigmented paint

R&F Handmade Paints
rfpaints.com | pigment sticks, encaustic tools and supplies

Jacquard
jacquardproducts.com | Pearl Ex Pigments, encaustic medium

Dick Blick
dickblick.com | Yes! Paste, Goldens Liquid Acrylic Glazing Medium, Small canvases, watercolor paper, Ink

For bonus demos, art and more, visit artistsnetwork.com/encaustic-revelation.

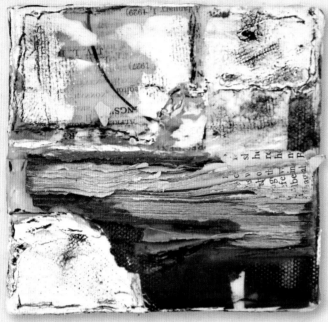

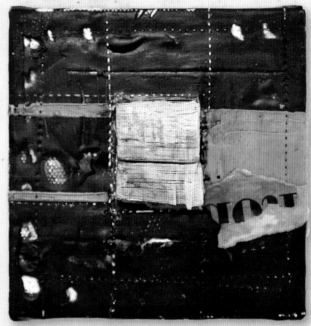

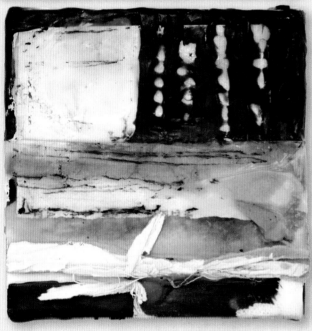

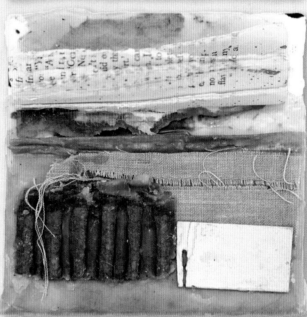

"When the artist is truly the servant of the work, the work is better than the artist; Shakespeare knew how to listen to his work, and so he often wrote better than he could write; Bach composed more deeply, more truly, than he knew; Rembrandt's brush put more of the human spirit on canvas than Rembrandt could comprehend. When the work takes over, then the artist is enabled to get out of the way, not to interfere. When the work takes over, then the artist listens."

—Madeleine L'Engle

HOT TIP
Working with common elements, a cohesive body of work can be developed. Each canvas may stand as a complete statement on its own while lending its part to a larger story.

For bonus demos, art and more, visit artistsnetwork.com/encaustic-revelation.

43

Judy Wise

printmaking with encaustics: monoprints and collographs

There's always an element of surprise in printmaking. I suppose that's what first attracted me to the tradition more than twenty-five years ago. The printed image you end up with is a mirror image of the plate you start out with. There is always a reaction of disorientation as you adjust yourself to the first print; this is my favorite moment.

Two printmaking techniques will be presented here. Both use beeswax to create either the printing surface or the paint medium. The prints we create using these techniques can be used as beautiful papers for related mixed-media work, collage arrangements or stand-alone prints.

In the collograph method, we'll use pure beeswax to create a plate that we'll ink and print on an etch press in the traditional method of using pressure to transfer the ink. In the monoprint approach, we'll apply colored waxes to a heated metal plate to make designs that we transfer to paper by applying gentle pressure with a brayer or handheld barren.

ENCAUSTIC MONOPRINTING

SUPPLIES NEEDED

anodized aluminum plate
brayer
heavily pigmented encaustic paint bars
hot palette or griddle
infrared or wax thermometer
oil pastels or Caran d'Ache crayons
roll of thin sumi paper or equivalent sheets or pads
shaping tools

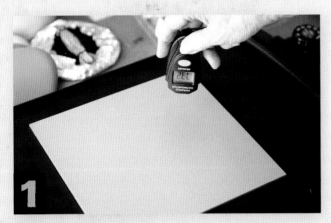

1

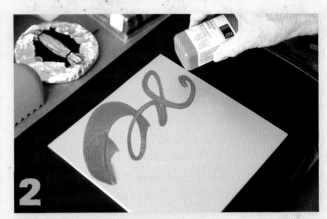

2

Place your aluminum plate on the griddle and heat the plate to 170°F (77°C). Use an infrared thermometer to confirm the temperature.

Create a pattern by drawing with bars of encaustic paint on the heated plate.

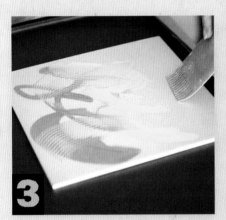

3

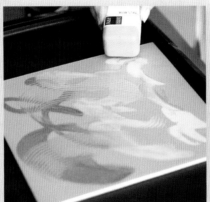

Manipulate the wax with various tools until you have a design you like, adding more color as desired.

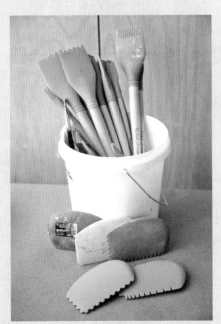

HOT TIP

There exists an almost limitless array of shaping tools you can use to create texture in your wax, including these silicone Catalyst tools from Princeton Artist Brush Co. They are especially suited to the job because the silicone is heat safe and won't scratch the aluminum. But feel free to use what you already have and what strikes your fancy—just be sure the base materials in your tools won't be affected by the heat or damaging to your aluminum plates.

For bonus demos, art and more, visit artistsnetwork.com/encaustic-revelation.

When you are satisfied with your design, lay a piece of sumi paper onto the plate and transfer the design onto the paper by gently rolling over it with a brayer, or transferring only parts of your image by gently pressing with your fingertips.

Carefully peel the paper from the plate by lifting from one corner.

HOT TIP

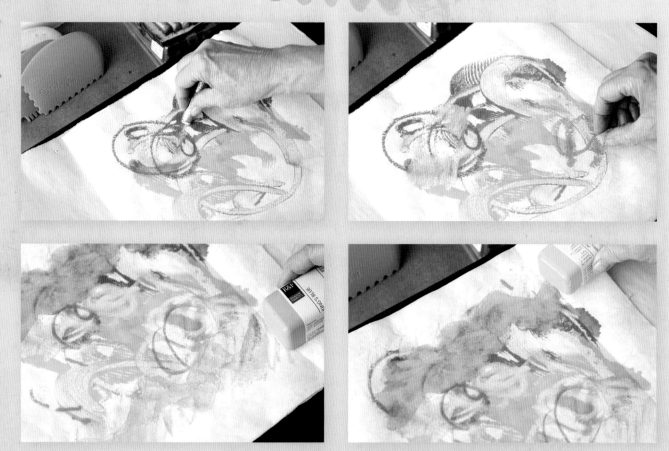

You can also overprint your prints. Try drawing into the print (while it is on the 170°F [77°C] griddle) with oil pastels or Caran d'Ache crayons. You can also add semitransparent layers of color in specific areas of your prints by lightly rubbing paint bars onto the surface. Again, the possibilities are almost endless, so let your imagination soar.

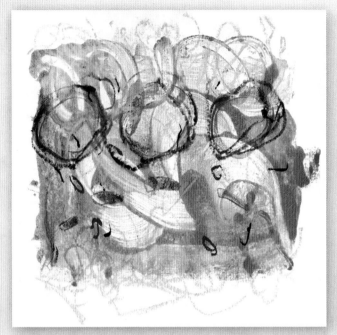 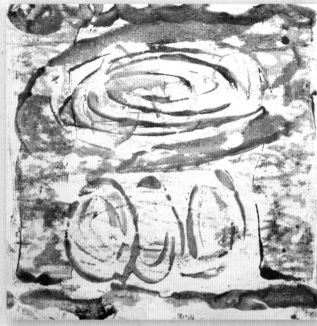

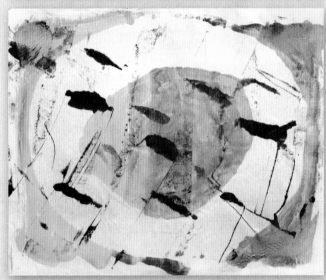 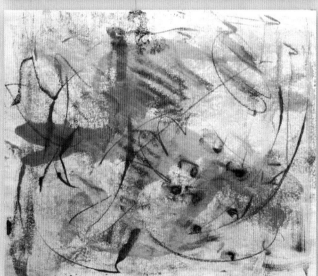

Little Skitter (top left)
Encaustic paint on paper
8" × 9" (20cm × 23cm)

Tidepool (top right)
Encaustic paint on paper
9" × 9" (23cm × 23cm)

Untitled (bottom left)
Encaustic paint on paper
9" × 12" (23cm × 30cm)

Swing (bottom right)
Encaustic paint on paper
9" × 12" (23cm × 30cm)

For bonus demos, art and more, visit artistsnetwork.com/encaustic-revelation.

ENCAUSTIC COLLOGRAPH

SUPPLIES NEEDED

acrylic plates, 0.118" (3mm) thickness

Akua inks and modifiers

Akua wiping fabric

beeswax

brayers

brushes

etching press

felts

heavily pigmented encaustic
paint bars

hot pot

metal file

newsprint

pencil

protective gloves

release agent

roll of thin sumi paper or
equivalent sheets or pads

shaping tools

spray bottle

tjanting tools

wax thermometers

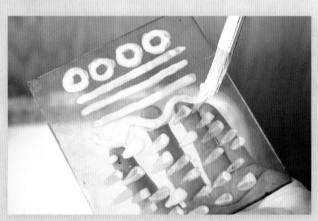

1 Heat pure beeswax (use only pure beeswax without resin; do not use commercially made encaustic medium) with white pigment powder added to 175°F (79°C) in a deep hot pot. While the wax is heating, peel the protective paper off both sides of your acrylic plate. Using a metal file, file all four edges of the acrylic plate to a 45° angle. This is to protect the felts on your etching press.

2 Create a design on the plate with the wax using various tools of your choice. Here I am using a basic natural bristle brush. Tjanting tools and Catalyst tools are also good options to consider.

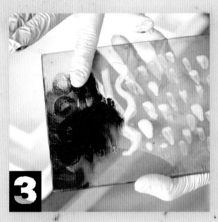
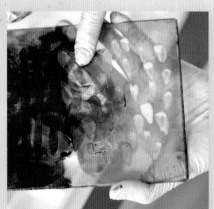
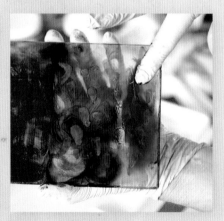

3 Rub a water-based printmaking paint (like Akua ink) onto the acrylic plate using gloved fingers. You may use several colors on the same plate, as I've done here.

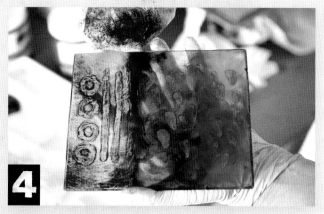

4 Wipe off the excess ink with a wiping cloth gathered in a loose bunch. Start with the lightest color and end with the darkest color.

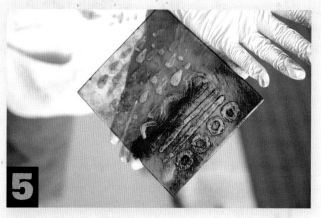

5 With your gloved hand, wipe across the plate very gently and with minimal pressure. This will remove any texture left behind by the wiping cloth.

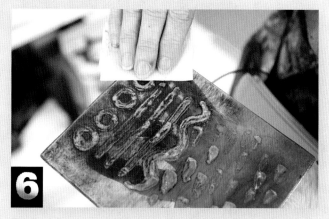

6 Finally, lightly press newsprint onto the plate to remove any lingering excess ink. Be sure to clean the edges of the plate.

7 Place the acrylic plate on the etch press.

8 Place sumi paper over the plate.

9 Place a double layer of newsprint on top of the sumi paper. (The paper protects the felts from bleed-through ink.)

HOT TIP

Dampen each sheet of sumi paper right before you print. Spritz your paper from a height of several feet. If the paper is too wet, it will stick to the wax, but if it's too dry, it won't pick up the ink.

For bonus demos, art and more, visit artistsnetwork.com/encaustic-revelation.

"People will stare. Make it worth their while."

—Harry Winston

10 Add a felt pad on top of the newsprint. Add pressure to the stack with your hand.

11 Adjust the pressure, and then run the plate through the press. This may take several trials to get the best amount of pressure.

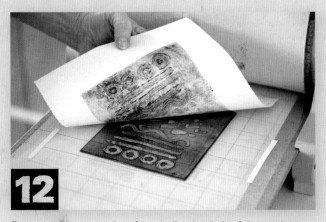

12 Remove the newsprint after peeling back the felts, and then carefully pull the plate off the paper.

Use a release agent to pull ghost prints from the plate. (A release agent is a product that re-activates the paint or ink.) Apply the release agent using a brayer, and then gently rub it into the ink with gloved fingers, being careful not to over-wipe. Repeat steps 7–11.

CLEANING UP

First, clean all materials, rollers and plates with a dry rag and follow with liquid dish soap right from the bottle. For final cleanup, water can be used. A rough textured rag works better than a smooth rag. Never add water directly to ink; water will cause ink to stiffen and makes cleanup more difficult.

For bonus demos, art and more, visit artistsnetwork.com/encaustic-revelation.

AKUA INK TROUBLESHOOTING

Your print dries milky gray instead of black:

- Thoroughly stir the ink in the jar from top to bottom before using.
- Stir the ink on the glass slab after each half hour.
- Your paper may be too wet—blot it with an absorbent cloth or sponge.

The ink dries too dark on the print:

- Add Transparent Base to the ink to reduce the color intensity.

The print dries too matte:

- Print on dry paper or paper that is less wet.

Etched lines bleed on the finished print:

- The paper may be too wet (blot before using).
- Try different types of paper.

Heavily inked prints dry slowly:

- Add magnesium carbonate to the ink.
- Dry the print between blotters or newsprint.

The ink wipes out from incised lines:

- The ink may be too loose (stiffen the ink by adding Mag Mix).

The print lacks plate tone:

- Print on damp paper.
- Wipe with less pressure (the plate may be over wiped).

The print has too much plate tone:

- Print on dry paper.
- Wipe more thoroughly.

The print dries blotchy:

- Dampen the paper.
- Avoid touching the inked surface of the plate and transferring fingerprints.

RESOURCES

Multi-Craft Plastics
multicraftplastics.com | acrylic plates

R&F Handmade Paints
rfpaints.com | heavily pigmented color blocks, beeswax, infrared and wax thermometers

Enkaustikos
encausticpaints.com | anodized aluminum plate

Dick Blick
dickblick.com | oil pastels or Caran d'Ache crayons, newsprint, brayers, felts, brushes

Glove Nation
glovenation.com | vinyl gloves

Patricia Baldwin Seggebruch
pbsartist.com | hot palette, tjanting tools

Home Depot
homedepot.com | wood rasps

Conrad Machine Co.
conradmachine.com | etching press

Akua Inks
akuainks.com | inks and modifiers, wiping cloths, release agent

For bonus demos, art and more, visit artistsnetwork.com/encaustic-revelation.

51

"All ideas grow out of other ideas."

—Anish Kapok

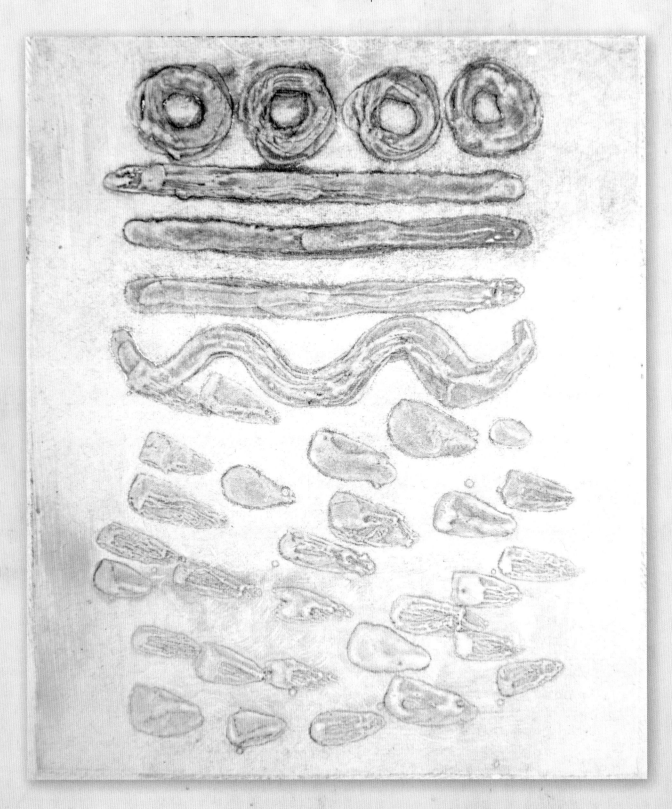

For bonus demos, art and more, visit artistsnetwork.com/encaustic-revelation.

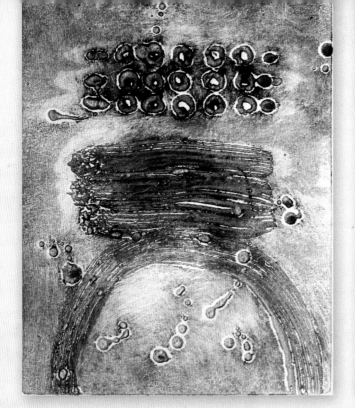

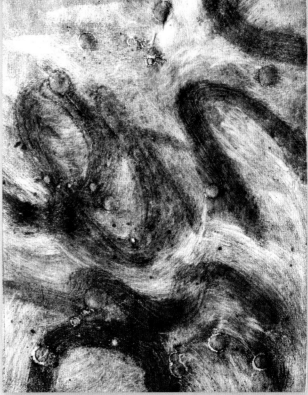

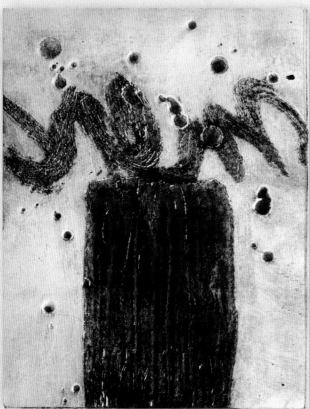

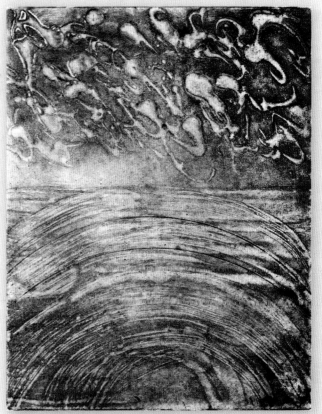

Align (top left)
Encaustic collograph printed with Akua ink on paper
8" × 6" (20cm × 15cm)

Coriolis Effect (top right)
Encaustic collograph printed with Akua ink on paper
8" × 6" (20cm × 15cm)

Fulcrum (bottom left)
Encaustic collograph printed with Akua ink on paper
8" × 6" (20cm × 15cm)

Perigee (bottom right)
Encaustic collograph printed with Akua ink on paper
6" × 8" (15cm × 20cm)

For bonus demos, art and more, visit artistsnetwork.com/encaustic-revelation.

Kathryn Bevier

the primary core and the encaustic landscape

SETTING UP YOUR PALETTE FOR PAINTING

My palette setup, color mixing and all the principles and methods I bring to creating and working a "picture plane" have their roots in my formal education.

At my palette's basic core are the primary colors; red, yellow and blue. Having a white, plenty of wax medium, and cleaning wax are also a must. Even still, there is a lot of flexibility in this palette lineup. As you know, these three primaries come in a wide range of colors. Your palette could be more traditional with Ultramarine Blue, Cadmium Red and Cadmium Yellow, or you might like a modern palette with Anthraquinone Blue, Naphthol Red and Bismuth Yellow. There are endless variations on this theme, such as using Quinacridone Magenta as a red, or Yellow Ochre for your yellow, or even limiting your blue choice to Cerulean. But the main idea and purpose behind the primary palette is for color mixing. Having a strong foundation to work from gives you a tremendous amount of freedom and flexibility. You will find that staying with fewer colors on your palette will help you control your color mixing and give you a cohesive quality because all your colors come from the same core. If and when you add more to your color selection, keep in mind that the primaries are your core and the other colors can be thought of as enhancers. Color mixing is like magic, and regardless of your style of painting, color mixing is almost inevitable, whether it is planned or not, so having a seemingly simple palette can yield the most beneficial results.

Find the right materials and tools that work for you. There are so many avenues in which you can work with encaustic, but having these fundamental guidelines will give you a place to start.

There are also many ways you can heat your paints and medium. I find a basic pancake griddle provides a nice flat surface to heat your tins of paint and gives you room for color mixing and paint extending. You can also regulate the temperature of the griddle to maintain proper working temperatures.

If you like to have a wide selection of paints in containers, you may opt for a second griddle—one for keeping waxes liquid and the other for the work surface.

With your palette plugged in and set to a temperature around 175°F (79°C), place your containers of paint on your palette and allow to melt. This should take about fifteen minutes. Your paints do not need to be thoroughly liquid to begin working, nor should your paints be so hot that they are thin and runny. I keep my palette at a lower temperature to maintain the paint's integrity and keep my studio environment safer.

For bonus demos, art and more, visit artistsnetwork.com/encaustic-revelation.

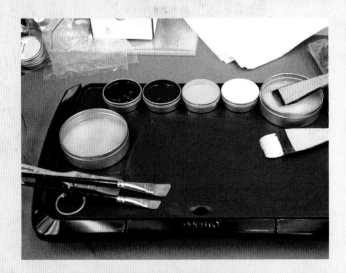

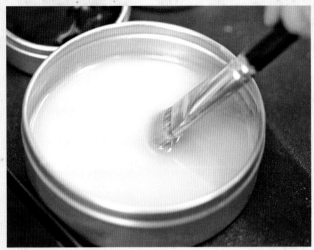

HOT TIPS

- I arrange the waxes in the same order on the palette, because this is very helpful in the mixing of colors. From right to left: wax medium, white, yellow, red, blue, cleaning wax.

- You will also need an additional heat source for fusing or bonding layers of wax throughout the application process, as well as natural bristle brushes, plenty of paper towels and an absorbent substrate. I typically use raw wood. Other items that are extremely useful are scraping tools and pottery loops.

- At any time, you can use encaustic paint that is not in containers, especially if you are looking for just a touch of a certain color instantly. By simply touching the paint to the surface of the griddle, the paint will melt.

- To keep your brushes clean in between colors, dip the brush in the cleaning wax and swish it around. Wipe away any excess wax from the brush with a clean paper towel.

- Having a brush designated for wax medium is a good way to ensure the wax medium stays uncontaminated by color.

- However you decide to paint, whatever your subject matter is, fusing between layers is always a good idea to bond the layers quickly and evenly and with little disturbance to your application.

- If your substrate is small enough, you can place it directly on the palette. Because the palette is hot, so too will be the substrate. Oftentimes, I will place one of my encaustic prints on the palette and paint directly on it. The benefit in this is that the paint will stay liquefied while the panel is on the palette, which allows for color mixing right on the surface of the panel and easy manipulation of the paint. Because wax has a self-leveling property when liquid, the surface rendered will be smooth. When you are satisfied with your painting, you can remove the panel or paper from the heated surface to cool off. At that point your piece is finished, or you can continue to build layers to create areas with more dimensional surface texture. (It helps to have a second griddle for this method of direct painting on a heated substrate.)

- To create texture with a brush, allow the paint on the brush to cool off and then, as in a dry-brush method, wipe in quick strokes across the painted surface. The wax paint on the brush will collect on the ridges of the underlying layers of wax paint and begin to build quickly, creating a nubbly texture.

- To create texture with scraping and pottery tools, use large, flat metal scrapers or pottery loops to scrape away the rough wax surface to create a flat, smooth surface. For incising and etching in line or details, use sharp metal picks of all shapes to carve into the wax surface.

For bonus demos, art and more, visit **artistsnetwork.com/encaustic-revelation**.

55

THE PRIMARY CORE

Enkaustikos hog bristle and slotted brushes

Enkaustikos Hot Cakes encaustic paint (I am using Ultramarine Blue, Naphthol Red, Bismuth Yellow and Titanium White.)

Enkaustikos Slick Wax or soy wax for cleaning

Enkaustikos wax medium

hake brushes

heat gun

pancake griddle

paper towels

pottery loop

raw wood panel

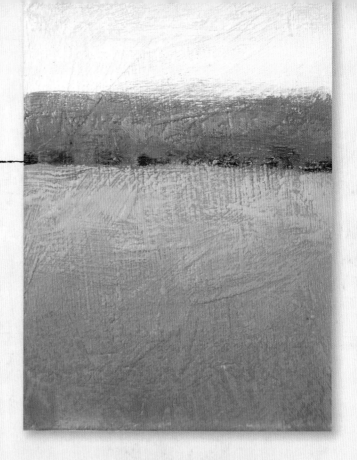

1 Coat a raw wood surface with a couple layers of wax medium making sure to bond the layers of wax medium to the wood's surface using a fusing tool. I am using a heat gun for this project. A hake brush is a good choice for applying your base coat of wax medium because it is useful in laying down thin layers of wax with minimal brushstrokes.

2 Dip your brush into your paint and then onto the palette. If you want to extend with wax medium, do the same step by dipping a clean brush into the wax medium and then placing it on the palette. Using your brush, mix the paint and medium together, adding more or less medium to create the desired paint strength. The more wax medium you add, the more transparent your paint will be. Your palette is your work space for mixing colors and extending paint with wax medium. The colors in the containers stay full strength and unmixed.

3 To mix colors together, simply place the colors you are mixing on the palette and mix, adding wax medium to create the desired consistency.

4 To make the green more natural, add just a touch of Naphthol Red to the color mix.

A good rule for color mixing is to limit your mixes to two or three paints. If you mix together more than that, you risk creating dull and muddy colors.

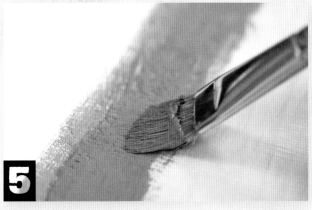

5 When you are satisfied with the color you have mixed, apply it to your substrate. Here I am using a hog bristle brush to lay down the paint because I want my brushstroke to add texture to the piece.

Repeat and develop your painting with each brushstroke, changing colors as needed or desired. Be sure to fuse each layer of wax as you develop your painting.

6 To create the color for the foreground, add more yellow to the green mix that is on your palette. The yellow will lighten and brighten this mix, which is what is needed for the field foreground. This new mix will be harmonious with the rest of the painting because you are using the same colors for all of your mixes.

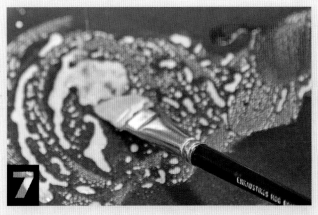

7 To this new yellow mixture, add just a touch of red to render a more realistic color. The flat surface of the griddle makes color mixing easy, and you can see how much red to mix in to achieve the desired color.

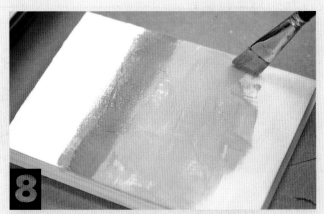

8 Using a hog bristle brush, apply the encaustic paint onto the substrate with brisk strokes going in a variety of directions. By loading up your brush with lots of paint, you can create more depth and texture.

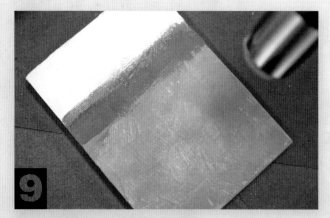

Fusing the layers of wax together with a heat gun is important to ensure that you are creating a structurally sound piece of art. Set the heat gun to low and move it in circular movements over the painting until the paint has been reheated to the point where it is bonded with the underlying layer of wax. You want a wet look and a slight relaxing of the wax.

To the other areas of the painting, apply the same color mixtures as you did for the foreground. Placing the same golden yellow used in the fields to the tops of the trees gives a sense of unity and dimension to the painting.

For further enhancement, add some blue and red to the mix to create a deep rich brown.

Using the tip of your brush, apply the rich brown mixture to the base of the tree line to help it recede.

A pottery loop is an excellent way to scrape off excess paint and reveal the underlayers of paint. In this case, it serves to break up the dark line for a more subtle effect.

For bonus demos, art and more, visit artistsnetwork.com/encaustic-revelation.

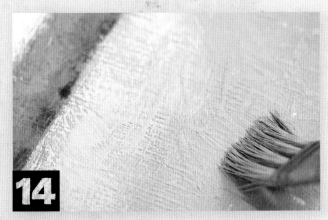

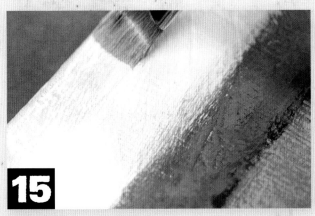

14

To build up texture quickly and effectively, use a slotted brush. The slotted brush has channels that allow the brush to hold even more paint than a regular brush, so laying down thicker layers of paint is more easily achieved. The slotted brush is also a great tool for creating a lot of nubbly texture. Load up your brush and then, with very rapid back and forth strokes, apply the paint to your painting. The new layer of wax paint will collect on the existing ridges of paint and begin to develop more dimensional texture. You can repeat this process as much as desired as long as you remember to properly fuse between layers.

15

After cleaning off your palette and brush with cleaning wax, mix a new color with Ultramarine Blue and Titanium White and build up layers of paint for the sky.

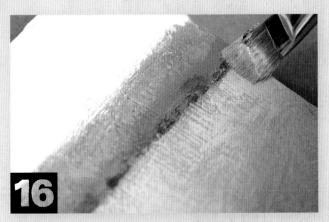

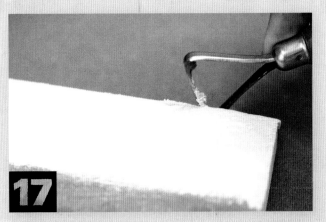

16

To create more unity in the painting and for atmospheric effect, carefully scumble a small amount of sky color over the distant hills, trees and where the field and trees meet. Always finish your painting with a final fusing, but take care not to overheat your wax in order to maintain the texture and design of your art.

17

Clean off the excess wax from the edges of the wood panel with a pottery loop.

For bonus demos, art and more, visit artistsnetwork.com/encaustic-revelation.

59

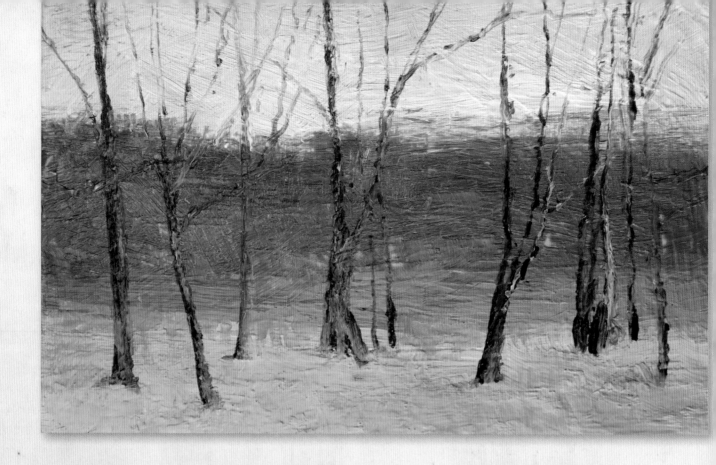

ENCAUSTIC LANDSCAPE WITH HOT TOOLS

Working with Enkaustikos Hot Tools allows you to apply paint at your own pace, create broad strokes of color or add very fine detail, and because they are also fusing tools, you will not need an additional heat source, such as a heat gun, for fusing. However, to begin you will want to prime your wood substrate with wax medium and fuse before laying down your paint.

All the Hot Tool attachments are made to thread onto a wood-burning tool. The Hot Tools thread onto the wood burner, the wood burner plugs into a temperature regulator, and the regulator plugs into an AC receptacle. The wood burner will heat up to temperatures that far exceed the proper temperatures for working with encaustic paint so you must use a temperature regulator. Turn the regulator to the "on" position, and, only as you need to, turn the dial to increase electrical supply to bring the Hot Tool to a proper working temperature. The desirable setting will maintain the wax in a liquefied state while on the tool and there will be no smoking or burning of wax.

SUPPLIES NEEDED

Enkaustikos C-Series Hot Pen attachments

Enkaustikos Hot Brush attachments

Enkaustikos Hot Cakes, Hot Sticks and/or Wax Snaps encaustic paint

Enkaustikos Slick Wax or soy wax for cleaning

Enkaustikos wax medium

hog bristle or hake brush

pancake griddle

pottery tools

raw wood panel

temperature regulator

wood-burning tool

For bonus demos, art and more, visit artistsnetwork.com/encaustic-revelation.

1 In preparation to paint the background of your landscape, thread onto the wood burner a No. 6 flat brass bristle Hot Brush attachment. After it heats up, dip the brush into paint that is already melted on the hot palette (griddle) and begin to mix your colors.

2 Starting with the sky and then working down the picture plane, mix colors on your palette for the background hills. Use a Hot Brush to build one layer of paint over another, taking care to work in one direction.

3 After the entire panel is painted, go back into the background to continue building layers of paint with subtle color shifts and texture.

4 Lightly dragging a clean Hot Brush over two colors softens and blends the edges and adds an atmospheric nuance to your painting.

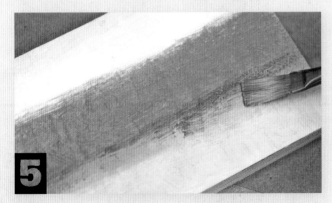

5 Use the Hot Brush to lay down the broader applications of the paint. Continue to blend by slowly dragging the Hot Brush over the layers of paint.

6 To clean your Hot Brush attachment, dip it into either Slick Wax or soy wax that is being heated on your griddle and gently swish to remove any excess paint. With a paper towel, wipe away any excess cleaning wax from your attachment.

When you are ready to add detail to your painting, thread a C-Series Pen point of your choice onto the wood-burning tool and allow it to come to the proper temperature by turning the regulator to the "on" position and increasing the electrical supply only as needed.

For bonus demos, art and more, visit artistsnetwork.com/encaustic-revelation.

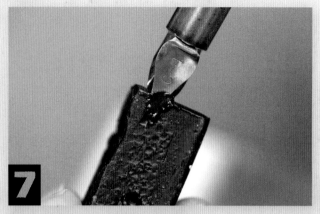

7

Another way to get paint onto the Hot Tools is by simply touching the Hot Tool to encaustic paint that is not liquefied. This is easy with the C-Series Pen Points because the tips are so small. Because the Hot Tool is hot, it will liquefy the paint upon contact. (Here I am using a C-4 Pen Point.)

8

After you have wax loaded onto the pen point, you can begin to apply it to your painting. The C-Series will create fine lines, similar to any sketching and drawing implement, as well as allowing for free-flowing calligraphic line.

9

Continue to lay down the trees by loading up the pen point with wax and then applying it to your painting.

10

Before using another color, you will want to clean your pen point. To clean the pen point, dip it into a cleaning wax and gently swish to remove the paint and then wipe with a paper towel. Repeat this process until the pen point wipes clean.

11

Continue to build up colors and details in the trees using the pen point until you are satisfied with the outcome. Because you are using Hot Tools, you are fusing layers of paint with each new application. The smallest detail is retained.

THE ENKAUSTIKOS WRITERS

The Enkaustikos Writers offer you the ability to create long, continuous lines. There are three writers to choose from, and each will yield a different size line: Wax Max, Wax Writer and Batik Writer. The writers thread onto a wood-burning tool just like the brushes and pen attachments do. You will need to use a temperature regulator with the writers.

The writers have a reservoir that holds a fair amount of wax in a liquid state. You can fill the reservoir in a variety of ways, but before you add wax to the reservoir, you need to make sure that the stylus that comes with the writer is in the reservoir, needle side down, fitting into the opening at the base of the reservoir. The stylus stops the flow of wax when the writer is not in use.

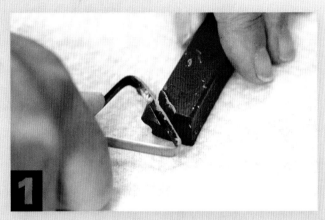

You can use a metal eyedropper to feed hot wax into the reservoir, or you can break off small chunks of solid wax to drop into the reservoir. Here I am using a pottery loop to break off chunks of paint from an Enkaustikos Hot Stick.

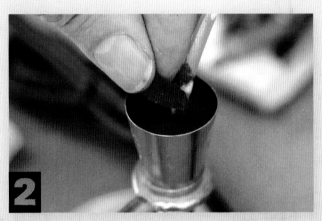

Add as much wax as you think you will need or as much as the reservoir will hold. The writer will be hot enough to melt solid wax paint.

After the wax is melted, touch the bottom of the reservoir to your substrate and move it to release the flow of wax. If you move in an up-and-down fashion, you will create dots. If you hold the writer down on the substrate and move it, you will create a line. When the writer comes in contact with your substrate, the stylus moves up, and the flow of wax begins. When you lift the writer off the substrate, the stylus slips back down into the opening at the base of the reservoir and stops the flow of wax.

Top to bottom: Batik Writer, Wax Max and Wax Writer.

For bonus demos, art and more, visit artistsnetwork.com/encaustic-revelation.

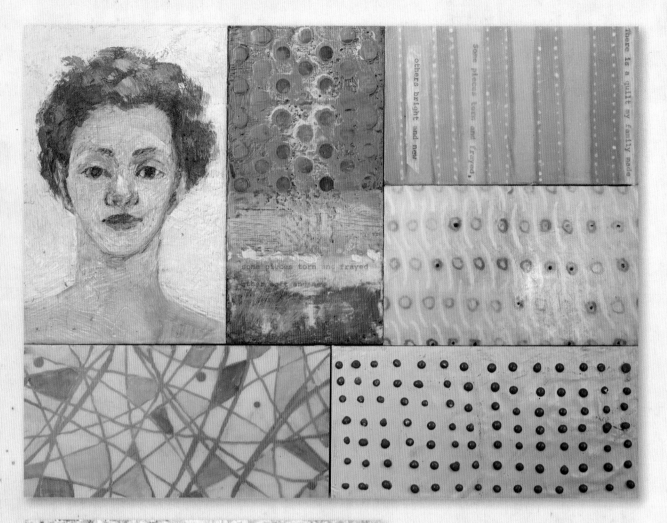

All of the above encaustic "quilt" pieces were created using Enkaustikos Hot Tools.

The texture in the piece to the left was created using a slotted brush and a pottery loop.

The pieces to the right were created with Enkaustikos Hot Tools and stencils.

The texture in the piece to the far right was created using a hog bristle brush and a pottery loop.

HOT BONUS

For a bonus demo of monoprinting with wax, visit artistsnetwork.com/encaustic-revelation.

RESOURCES

Enkaustikos
encausticpaints.com | Hot Cakes, hog bristle brushes, slotted brush, Wax Medium, Slick Wax, Hot Sticks, Wax Snaps, Hot Brush attachments, C-Series Hot Pen attachments

Fine Art Store
fineartstore.com | hake brushes, raw wood panel, temperature regulator, wood-burning tool, pottery tools

For bonus demos, art and more, visit artistsnetwork.com/encaustic-revelation.

65

Michelle Belto

encaustic 3-D: sculpting with foam and wax

There is something so appealing about sculpture. Maybe it is because so much of our world is three-dimensional, from the cups that hold our morning coffee to the furniture we select for our homes. Making sculpture—working with materials to create a three-dimensional form—is an immensely rewarding experience. From prehistoric time we have decorated our spaces with monolithic representations of animals and emperors and peopled our world with effigies of deities and spirits. Artists throughout history have carved stone and wood, modeled clay and cast plaster in processes that are both tactile and totally hands-on.

We don't often think of encaustic with sculpture, but much of the marble Greek statuary was originally painted in brightly colored pigmented wax. Although most of the color is now lost to time, we have images on vases that show artists painting statuary with wax. I've wanted to be a sculptor for a long time, but I wasn't drawn to any of the traditional materials that sculptors use. Because I work in handmade paper and wax, I wondered if I could use traditional sculptural processes with the materials that I like best. Voilà! I discovered EPS (expandable polystyrene) foam—an inexpensive, nontoxic material commonly found as computer packaging. I didn't have to chisel marble or sculpt wood to get the full effect of carving. With a block of foam and a hot knife, you, too, can become Michelangelo! I have to warn you: This is a totally addicting process.

In this chapter we are going to combine the ancient process of carving with encaustic painting to create three-dimensional art that draws from the strength of stone while maintaining the absorbency that is needed for the wax. You will make work that appears solid and heavy, but is actually feather light. The foam becomes the form, but in order to accept the wax, it needs an absorbent skin. For the skin, we will be using plaster gauze, the same material that the doctor uses on broken arms. You will be amazed at what you can create with these two simple and easy-to-use materials.

SOME THINGS TO REMEMBER ABOUT FORM

- Sculpture needs be interesting on all sides.
- Sculpture needs some engineering because it has to be self-supporting, so have a plan!
- Sculpture usually works with an armature and a skin. The type of armature and the choice of skin should inform your idea.
- If using an armature, it should be totally secure *before* you put on its skin.

CARVING

SUPPLIES NEEDED

EPS foam block (EPS is sold commercially in craft stores and online under the trade name Smoothfoam. You can also purchase sheets at a home improvement store or use discarded white packing material found with computers or other electronic equipment.)

heat gun

heavy gel medium

Hot Wire tools or Hot Knife: (tools pictured are from Hot Wire Foam Factory)

roll of plaster cloth cut into 1" (25mm) strips (found at craft stores)

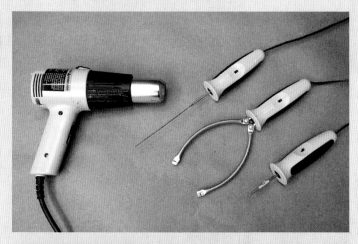

CARVING TIPS

- Solid armatures suggest qualities of permanency, strength and longevity.

- EPS is the only foam that can be carved without health issues. On the carcinogen scale, EPS is the safest of all foams.

- It is best to draw your design on paper before you begin. Carving is a subtractive process, and mistakes are easy to make.

- After your design is fixed in your mind, you can sketch it on the foam to offer greater security in cutting. Make sure there is some negative space in your design.

- The hot knife is very hot. It doesn't take long to heat up after it is turned on. Let the knife do the work. You just need to guide it.

- Make sure there are several planes so there is interest on every side.

- After you have completed the cutting, clean the knife with a thick wad of paper towels before you turn it off. Always turn off the knife before you lay it down.

- If your design will take up more space with less mass, you might need to reinforce the core with ½" (13mm) foam core and glue the EPS around the foam core.

For bonus demos, art and more, visit artistsnetwork.com/encaustic-revelation.

67

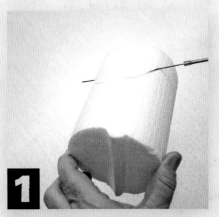 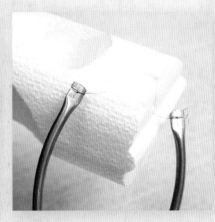

1

After you have your design firmly fixed in your mind or drawn on the foam, begin to cut away what you don't want. The knife is supposed to glide easily through the foam. Don't use pressure or force. Let the hot blade or wire do the work.

Different tools are designed to cut in different ways. You can begin with a simple hot knife or hot wire tool, but if you like the process, you can invest in a wider variety of cutting instruments. You can also use a heat gun to soften edges.

SAFETY TIPS

- Make sure you read the manufacturer's information sheet for the hot tool that you are using before you begin.

- Establish clear safety steps for yourself, such as always turning off the tool and allowing it to cool for a minute before laying it down.

- Make sure that tools are placed only on heat-resistance surfaces.

- Hot tools are *hot*. If you inadvertently touch the knife blade or wire when it is on, you can receive a severe burn.

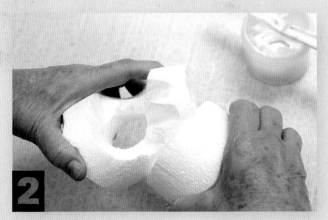

2

If your sculpture needs a base, you can use heavy gel or matte medium to glue your form to a foam base. Allow the gel to set up and dry for at least 6 hours.

3

Cut the roll of plaster cloth into manageable 1" (25mm) strips. Activate the plaster by dipping the strip into a bowl of warm water.

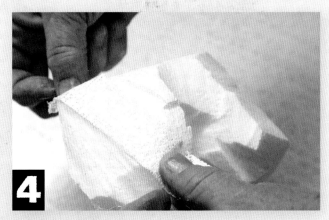

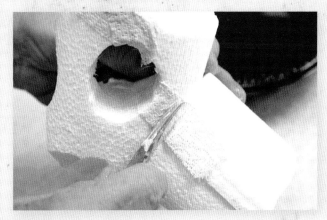

4

Carefully apply the strips over the entire form, including the base. Complete one area before moving on to the next area because the plaster begins to harden almost immediately. Overlap each plaster strip with the next strip to ensure that you are covering the foam completely.

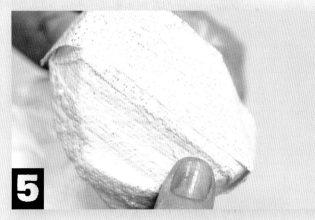

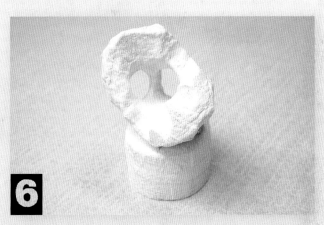

5

As you apply the strip, rub your finger over the plaster cloth to smooth out the plaster. You won't be able to get a completely smooth surface, but the more plaster you can smooth over the cloth, the stronger your finished work will be.

6

Allow your finished sculpture to dry overnight before applying wax.

HOT TIP

Instead of using plaster cloth, try using strips of wet, fresh paper with methyl cellulose as the adhesive. If you don't have access to fresh paper, you can also use paper for printmaking. Look for thick sheets with 100 percent cotton linter and little or no sizing. Spritz on both sides with water and wrap in plastic for an hour before using to allow the water to penetrate the paper. The process is the same, but the effect is different.

For bonus demos, art and more, visit artistsnetwork.com/encaustic-revelation.

69

WAXING THE SCULPTURE

SUPPLIES NEEDED

- alcohol inks
- cooking oil
- dedicated medium brushes
- electric griddle for heating wax
- encaustic medium
- ink
- mark-making tools
- oil pastels
- paper towels
- protective gloves
- scraping and carving tools
- translucent oil paint or pigment sticks
- wax glazes
- watercolors and watercolor brush

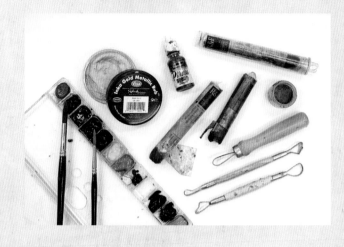

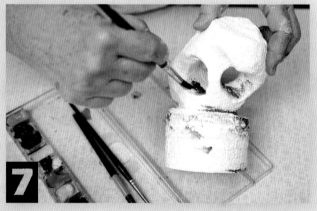

7

Before you apply wax, you might want to add some color by painting watercolor directly onto the form. You can use this approach to enhance shadows in some areas or to highlight other areas.

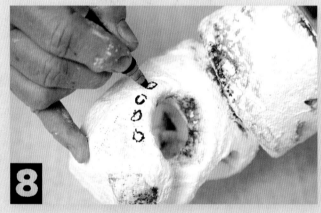

8

You can also add some interesting marks using ink or a marker. These early marks and colors will become hints of color and background imagery after you apply the translucent wax and oil.

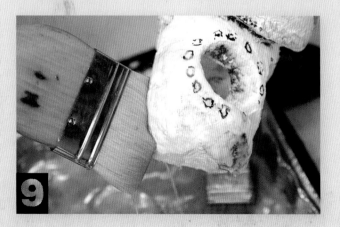

9

When your underpainting is dry, apply a coat of medium over the entire surface of the sculpture. Don't try to get this first layer smooth and even. You will need to build up layers.

10 Allow your first layer of wax to cool completely. Apply a second layer of wax over the cooled layer.

11 Fuse this second layer of wax to the first by moving your heat gun slowly over the entire surface. Because you are working on a three-dimensional form, your wax will be inclined to run, so fuse lightly—that is only until you see a shine. A shine means you have adequately fused one layer to the next. Running wax means you are melting several layers of wax.

12 After your form is fused and cool, use a scraping tool to remove any drip marks or wax accretion that you don't want.

13 Add a light wax glaze as a beginning step. Mix a small amount of encaustic paint with encaustic medium to create a transparent glaze. Paint your sculpture with the glaze and then fuse lightly.

HOT TIP

Accretion is a process of adding wax onto wax, sometimes intentionally and other times not. If you drag a brush of semi-cool wax over a waxed surface, the wax will accumulate in textural marks. If you fuse a vertical surface, the wax will drip. Both would be considered accretions. Whether you scrape those accretions off your sculpture or incorporate them into the finished work is a design choice.

For bonus demos, art and more, visit artistsnetwork.com/encaustic-revelation.

71

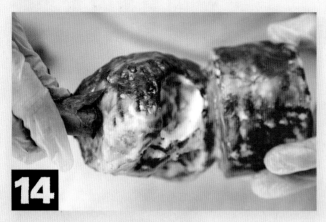

14 Use a neutral gray or graphite oil paint or an oil stick (I am using R&F Pigment Sticks in this demonstration) for this step. Use gloves to protect your hands. Apply liberal amounts of pigment to the entire surface of your work.

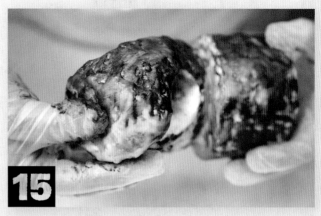

15 Use your gloved fingers to press the oil into all of the textural pores.

16 Pour a bit of cooking oil onto a paper towel.

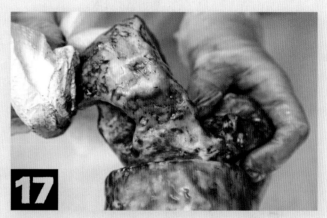

17 Wipe off most of the dark oil paint or oil stick from the surface of your sculpture. You want the neutral color to enhance the depth of the surface, so don't try to get off all of the oil paint, but do get off as much of it as you can. When finished, fuse, cool and add another layer of clear medium.

18 Repeat steps 13–17 as many times as you want using different colors of translucent oil sticks to get the layers of color that create a lovely depth.

19 Between each layer of pigmented oil, add another layer of clear medium.

20 Both the oil and the medium should be fused lightly. Always make sure your sculpture is completely cool before applying another layer of oil color.

21 When you have built up a surface that is to your liking, you can add some final touches with a variety of mixed-media materials.
- Mica powders add an area of glimmer and highlight.
- Alcohol inks can add an area of contrast, as the alcohol ink dries shiny against the matte surface of the wax.
- Oil pastels can be used to draw lines and make marks.

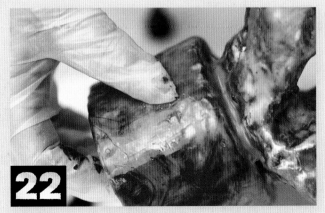

22 Check your sculpture for anything not to your liking, then give it a final light fuse. You are now ready to show off your finished art!

*"Art enables us to find ourselves
and lose ourselves at the same time."*

—Thomas Merton

For bonus demos, art and more, visit **artistsnetwork.com/encaustic-revelation**.

73

THREE TIPS TO CREATING WELL-DESIGNED SCULPTURE

Have a CONVERSATION with SPACE: Your sculpture should make a statement in space, either by the way it occupies space—extending or moving through space, or by the way it encloses or enfolds space—creating hollows or voids within the form, or by how your forms relate to one another in space. A good sculpture should draw us into its orbit, compelling us to want to move around it and look into it or through it.

Match your MASS with your MESSAGE: Your mass—think of a "mass of dough"—should reflect your idea in size, visual weight and materials. An Alexander Calder mobile would be more likely to communicate fragility and movement, while the giant Stonehenge sculptures communicate permanence and ritual.

Season your Sculpture with TEXTURE: Find ways to add visual texture, whether it is inherent in the materials (such as the grain of wood or the mesh of wire) or is added to the surface in marks or in relief. A sculpture should make us want to touch the surface.

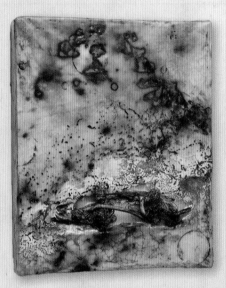
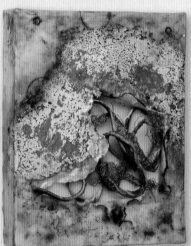
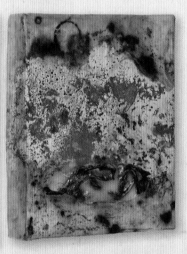

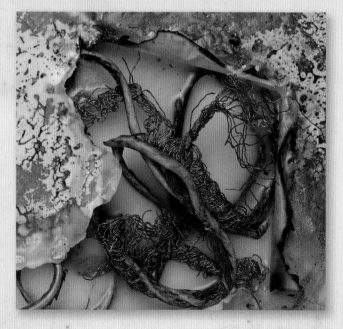

RESOURCES

Hot Wire Foam Factory
hotwirefoamfactory.com | EPS foam blocks and tools

R&F Handmade Paints
rfpaints.com | pigment sticks and
encaustic medium

Liquefaction
Encaustic, oil, shellac, found object on artist-made paper
27" × 12" (69cm × 30cm)

For bonus demos, art and more, visit artistsnetwork.com/encaustic-revelation.

Clockwise from top left:

Sculpture Study #1

Encaustic and oil on carved EPS and artist-made paper,
14" × 8" × 4" (36cm × 20cm × 10cm)

Sculpture Study #2

Encaustic and oil on carved EPS and artist-made paper,
9" × 6" × 3" (23cm × 15cm × 8cm)

Sculpture Study #3

Encaustic and oil on carved EPS and artist made paper,
7" × 5" × 6" (18cm × 13cm × 15cm)

Patricia Baldwin Seggebruch

dyed in encaustic: indigo and procion

In 2010 I was lucky enough to pay a visit to Jacquard Products in Healdsburg, California. At the invitation of (or did I invite myself?) Sue Stover, a then-seasoned Jacquard employee, I spent three days with the staff, products and space that is Rupert, Gibbon & Spider, Inc.

Experimentation overload occurred!

As Sue dipped, dyed and tried different fabrics to show me the wonder of Procion and the oh-so glorious Indigo, I had to do it; I dipped in Encausticbord, and alas, *Dyed in Encaustic* was born!

I began in textiles, way back in seventh grade. I made a beautiful Gunne Saks-style dress for "graduation." I've since sewn, dyed, batiked and distressed my way through many a textile, so this wasn't new information for me per se; just a reintroduction that was eye opening in its potential with encaustic!

Tests were done, crazy experiments conducted, flagship *Dyed in Encaustic* workshops held, and alas, the technique was fully born! EncaustiCamp 2013 is the breeding ground for its expansion across the globe. As this next round of EncaustiCamp workshops begin (rotating through for two years before changing up), I expect *Dyed in Encaustic* to flood the encaustic world as another fantastic way to bring color, texture, depth and dimension to the wax. It's the truth of what I am inspired to tell about encaustic after all; that it is all-inclusive of every other make, model and mode of art, and there's a voice for every creative inkling within its waxy goodness. So come, join me here. Plan to get waxy; but let's start with a good dyeing!

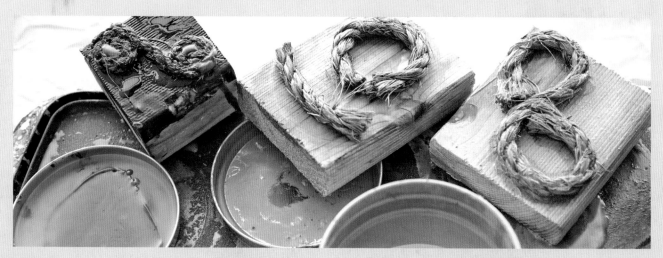

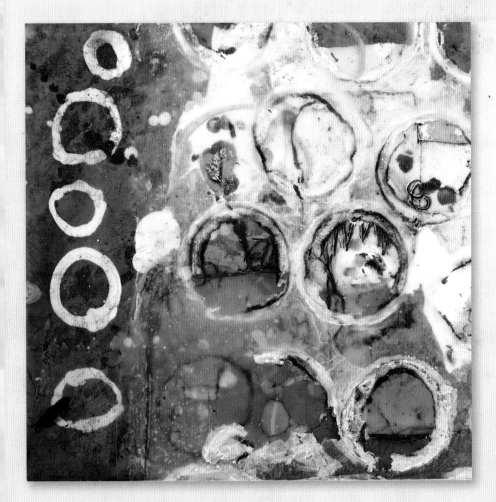

In the Mysteries

This is one of the first to come out of the vat while playing at Rupert, Gibbon & Spider, Inc. I later took it back to my studio, and had my way with collage, incising, pigment sticks and more wax. *In the Mysteries* was born!

SUPPLIES NEEDED

encaustic paints and mediums
Encausticbord or plastered board
Jacquard Indigo Tie Dye Kit or your own indigo bath
paint stir sticks
plastic containers large enough to hold submerged bords
tjanting pens
wax stamping tools

MATERIALS TIPS

- Although other surfaces take indigo well, Ampersand's Encausticbord is the most receptive and most beautiful for this process. I have tried plain birch panels, plastered panels and self-gesso, and alas, there is just nothing like Encausticbord!

- You will need a container for the indigo that will allow you to fully submerge the Encausticbord. I have done this technique with up to 18" × 18" (46cm × 46cm) bords, but prefer to work with 8" × 8" (20cm × 20cm) because it is easy to find a lidded Rubbermaid container in an appropriate size!

For bonus demos, art and more, visit artistsnetwork.com/encaustic-revelation.

77

CREATING PLASTER BOARDS

An alternative to using Ampersand's Encausticbords is to create your own similar work surface. You can do this very easily and inexpensively. Spread spackling paste or Venetian plaster (both available from a home improvement store) or encaustic gesso to the surface of a board; you can use a cradled board but it isn't necessary to do so. Try to minimize knife or spreader marks, but sometimes such marks can add an interesting layer of texture to your work. Let the paste or plaster dry completely. If you need to remove knife marks after the board has dried, lightly buff your surface with sandpaper. Wipe off the dust with a soft cloth or a tack cloth.

On the left is a plastered and dyed board with palette knife application marks still evident for added texture in this first layer. On the right is a board created in the same manner, but sanded smooth before dyeing.

For bonus demos, art and more, visit artistsnetwork.com/encaustic-revelation.

PREPARING YOUR BOARD

The full beauty of dyeing the Encausticbord is the resist, or "left white" areas that cause the indigo to fully shine. You can, of course, submerge an Encausticbord in the vat and end with a fully indigo bord, but the value of the contrast is not to be missed!

There are numerous effective means to achieve this resist for dipping. It can be as simple as using masking tape in designated areas to resist the dip, to my favorites, applying tjanting pen and handmade batik stamps. I have even experimented with contact paper and contact cement effectively; just make sure you remove these resists before starting the encaustic process!

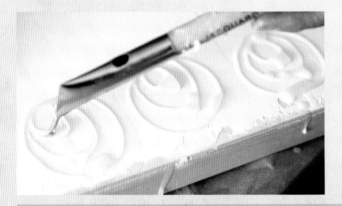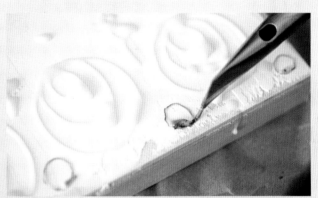

Tjanting Tools: You can use traditional tjanting tools (also known as batik pens) to create your resist pattern. (They are also great for adding linework to your encaustic paintings.) To create a resist pattern (or an area that will remain white after dyeing), just fill the pen's reserve with wax and draw or write on your board. You will have to return the tool to the wax frequently because as the tip cools down, so will the wax. You also need to hold the pen at a slight angle, not straight up and down. Tjanting tools come in small, medium and large sizes; the one shown on the left is a medium-sized tjanting tool filled with white encaustic paint. In the photo on the right, I'm using a small tjanting tool filled with colored paint. Enkaustikos makes electric, continuous-flow tjanting pens, the Wax Writers and Wax Max. These are fabulous as well.

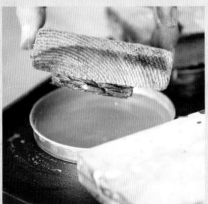

Handmade Stamps: You can also use handmade stamps, like the ones shown here. Glue lengths of rope to small wood blocks. Then simply dip the stamp into the wax and stamp it onto your bord to create a simple resist pattern. After you are satisfied with the design and your wax has cooled, your bord is ready for dipping.

HOT TIP

It is not necessary to fuse (nor is it recommended) these stamped or tjanting-pen resists before dyeing. You often run the risk of distorting your image, and after the piece is dyed and dry, these resists will be removed anyway.

For bonus demos, art and more, visit artistsnetwork.com/encaustic-revelation.

79

PREPARING THE INDIGO

Begin by mixing up the indigo vat. Directions on this process are very clear on the Jacquard Indigo Kit packaging. To simplify, I fill my dye container with warm water to my desired water level, add in the two packets of activator, stir until dissolved, add the indigo, stir gently so as to not let in too much oxygen, put the lid on and allow to rest for about an hour.

Upon opening the lid and seeing a beautiful, nearly neon green tone and central bloom, it is time to begin dipping!

While you wait for the delicious blue goodness of the indigo to develop, prepare your Encausticbords.

HOT TIP

Please wear disposable gloves for dyeing! Jacquard provides them with the Indigo Kit, but in case you have misplaced them, find another pair! Your hands will be forever blue, not to mention the indigo can absorb into your skin and cause health risks; be mindful of your own process so as to ensure safe practice!

VAT DIPPING: INDIGO

Remove the lid from the indigo vat and stir gently. Slowly dip one side of the Encausticbord into the vat, making sure to not disrupt the vat or its contents too much; doing so will add oxygen to the mix, shortening its working life.

Allow the bord to fully submerge and leave it alone for anywhere from a few minutes to an hour. The length of time the bord remains submerged will determine the depth and intensity of color.

You can use a dedicated wooden spoon, paint stirrer or other tool to help submerge and position the bord in the indigo vat.

HOT TIP

Do not leave the bord in the vat for longer than an hour. It will begin to warp from the moisture if left too long.

For bonus demos, art and more, visit artistsnetwork.com/encaustic-revelation.

When you are ready to remove the bord, make sure you have your gloves on. Remove the lid and gently insert your hand, so as to not disrupt the oxygen content, and retrieve your bord! Again, feel free to use a wooden spoon, paint stirrer or other tool to aid in the removal process, but remember, you can't use that tool for anything other than artistic purposes ever again. Admire the change of color that is unique to indigo; upon contact with oxygen as it is removed from the vat, the indigo begins to turn from the electric green to its trademark blue.

Often after I have admired my bord for a bit, I take it to the sink and give it a rinse. This removes any residue that can contaminate the encaustic medium or paint if left on the bord. This is not, however, mandatory for a satisfying end product. You can, if you prefer, allow the bord to air dry and then paint onto the unrinsed surface. This sometimes gives me greater patterning of the indigo bloom and dip that occurs. Just make sure when applying wax over these unrinsed bords that you are mindful of residue pickup on your brushes.

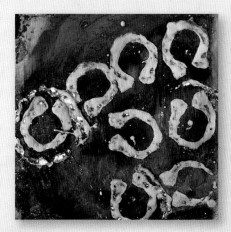
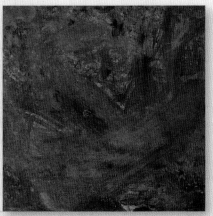
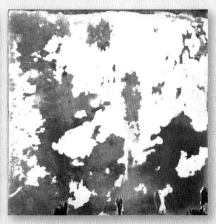

This is a sample bord using a rope stamp to create a resist pattern.

This is a plain bord without a resist that has been dyed with indigo.

This is a plastered bord (without a resist pattern) that has been dyed and sanded.

"Never give up on what you really want to do. The person with big dreams is more powerful than one with all the facts."

—Albert Einstein

For bonus demos, art and more, visit artistsnetwork.com/encaustic-revelation.

81

VAT DIPPING: PROCION DYES

Dyeing with Procion dyes is an easy and versatile process. Because I want the vat to be as intensely colored as possible, ensuring a great concentration saturating the bord, I fill my plastic tub with a few inches of water—enough to submerge the bord into—then I dump in the entire contents of my Jacquard plastic jar of dye. Stir and dip!

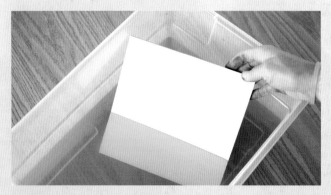
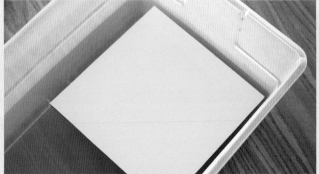

You can dye an unprepared bord, as in this example. The process is similar to dyeing with indigo; gently dip one edge into the vat and then fully submerge it to avoid splashing and forever coloring your clothing. You can let it soak for anywhere from a few minutes to an hour. The length of time will determine the intensity of the color absorption.

A dyed bord that has no resist gives you the option of alternative foundation techniques in addition to dyeing before coming to the wax. You can treat it like a batik, adding tjanting tool lines or stamp marks once dry and then redyeing, or make marks with charcoal, graphite or PanPastel, either before or after dipping for added foundation interest.

In this example, masking tape is used as a resist. As you can see, some of the dye seeped under the tape, but the shading and patterning resulting from this kind of resist is unique.

Here's an example of dyeing a bord that has a resist pattern added. In fact, this bord has two different colors of wax applied as resists.

VAT DIPPING: OVERDYEING WITH WARM BLACK PROCION

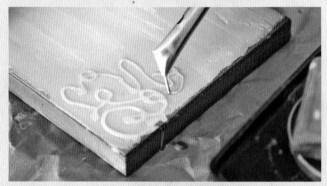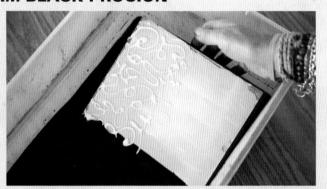

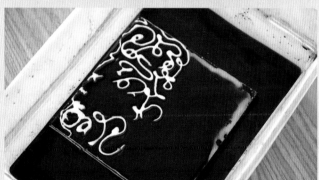

Not completely pleased with your dyed bord? Disturbed by the bold, bright color of a hot pink dip? No worries. I always make sure I have a Warm Black Procion vat on hand for just such an emergency. Warm Black is a delicious blend of primaries that, when used as a toning-down agent over too bright, too bold or just ugly colors, creates beauty! It tempers the color and tones everything down to a delicious beautiful every time. And notice in the sample on the right that you can also see the original bord color through the applied wax design. How cool is that?

For bonus demos, art and more, visit artistsnetwork.com/encaustic-revelation.

83

POST-DYEING TIP

If you have used a resist in the first layer or between layers and you want to remove the wax resist to expose a color or start your next step with a smooth, clean bord, you can melt the wax off the bord with a heat gun.

PAINTING

Time to paint! I suggest you always prime your bord with encaustic medium before proceeding with creating your masterpiece. After this foundation is set, it secures the indigo (or Procion) dye and will prevent it from potentially bleeding into subsequent layers.

You can now add any number of the dynamic possibilities of techniques in encaustic! Indulge in your favorites: incising, image transfer, shellac burn. Or come at it with something new, perhaps one of the other incredible techniques from the pages of this book!

Stem to Stern

I love stencils! This piece began with a stencil as a resist into the indigo vat. Delicious collage elements were once again put into play with my favorite incising in the encaustic layers.

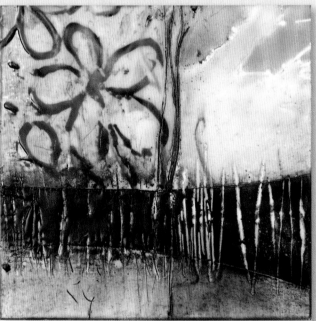

Hand Drawn

Hand Drawn began in my studio before my studio became a temporary, mobile place. Procion dyeing began the composition with tjanting tool flowers and then I applied lots of encaustic techniques to pull it all together.

For bonus demos, art and more, visit artistsnetwork.com/encaustic-revelation.

Paperthread Procion
Random line work with tjanting pens was done on this Encausticbord before multiple dips into the various dye baths took place. With collage and incising added, I called it complete!

RESOURCES

Ampersand Art Supply
ampersandart.com | Encausticbords

Enkaustikos
encausticpaints.com | paints

Jacquard
jacquardproducts.com | dyes, tjanting tools, indigo kit

R&F Handmade Paints
rfpaints.com | pigment sticks

For bonus demos, art and more, visit artistsnetwork.com/encaustic-revelation.

85

Shary Bartlett

hot fabrications: sculpting with fabric, fiber, lutradur, tyvek and beeswax

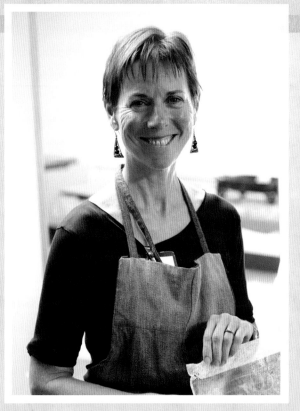

When I was a teenager, I loved creating art from textiles and fibers: I shivered under the drape of a hand-sewn silk blouse; delighted in the sharp snap of a tightly embroidered French knot; sunk my nose deep in the earthy aroma of sheep's fleece, fingers spinning the tangled mass into yarn. And does anyone remember macramé?

As an adult with "grander" passions, I forgot my love of textiles for decades, until one day, in that way life has of tossing coincidence our way, I stumbled back onto fiber arts, falling in love once again. At the time, I was having a hot affair with encaustic wax, so why not try two-timing, I wondered? Perhaps fibers and wax might find passion in one another!

For every success in merging the two, I created numerous monstrosities, but eventually I found textiles and wax could indeed form a happy marriage, each bringing out something new and exciting in the other. With brave experimentation, you, too, will discover stunning combinations. Remember: Never underestimate the power of happy accidents!

Safety Measures for Heat-Distressing Fabrics and Spunbonded Fibers

- When using any art materials, health and safety concerns are of the utmost importance. When heat-distressing fibers, work outside and upwind of your work surface to ensure any fumes are carried away from you. Manufactured fabrics and spunbonded fibers can be toxic when heated. Wear a respirator mask and gloves. Be careful not to burn the fabric to the point of flame, and keep a fire extinguisher close at hand.

- Use a heat gun, not a torch, because fibers and fabric blaze quickly under open flame.

"Nobody sees a flower—really—it is so small. We haven't time—and to see takes time, like to have a friend takes time. So I said to myself—I'll paint what I see—what the flower is to me; but I'll paint it big and they will be surprised into taking time to look at it."

—Georgia O'Keeffe

For bonus demos, art and more, visit artistsnetwork.com/encaustic-revelation.

Severed Beauty

At first glance this sculpture appears to celebrate the splendor of cut roses. The waxed fabric petals, however, are powdered with pigment, symbolic of pesticides used in the floral industry. These chemicals raise serious health concerns for low-wage workers, consumers and the fragile bees that pollinate the flowers.

(polyester, encaustic medium, Pearl Ex Pigment Powder)

SCULPTING FABRIC, FIBER AND BEESWAX

Wax lends fabric amazing sculptural properties. Cloth can be shaped, twisted and bent into myriad forms. Dipped in clear encaustic medium, these will take on just about any rigid form you desire! Here, I'm creating a bed of roses on cradled hardboard.

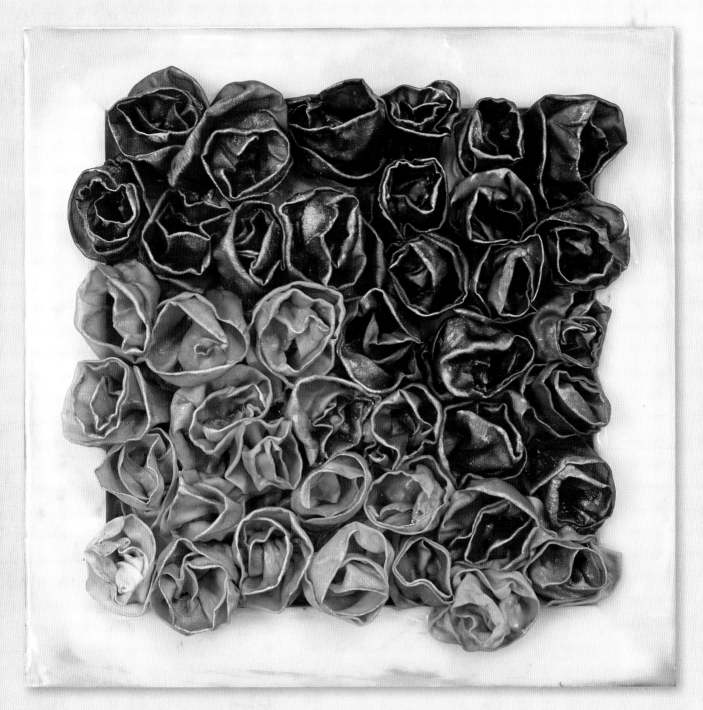

For bonus demos, art and more, visit artistsnetwork.com/encaustic-revelation.

87

SUPPLIES NEEDED

- bristle brush
- cradled panel
- egg carton
- electric skillet
- encaustic medium
- heat gun
- mask
- painter's tape
- Pearl Ex Pigment Powder
- polyester fabric in multiple colors
- protective gloves
- printmaker's tin or old tuna can
- roll of thin sumi paper or equivalent sheets or pads
- scissors
- stapler
- tweezers

HOT TIP

Polyester and silk are stunning when dipped in medium. Lighter fabrics, such as organza, do not contain enough fiber to hold the wax; conversely, some heavier fabrics look too textured and chunky when waxed. When submerged in wax, some fabrics transform from sensuous cloth to ugly ducklings. Rummage through that dusty box of textile scraps in your attic (I know you have one) and give them a dunk! You'll find some work beautifully.

 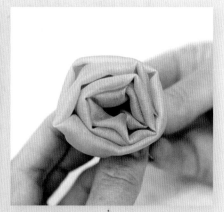

1 Cut approximately 3½" × 10" (9cm × 25cm) lengths of polyester in different colors and wind each around your fingers to form a single rosette. Ensure you have more rosettes in a variety of colors than fit into the well of your cradled panel.

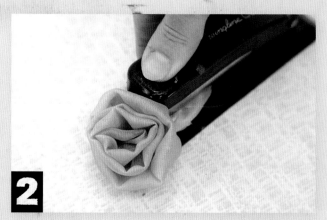

2 Staple or sew the base to hold in place. Form all the rosettes before proceeding.

3 Dip the rosettes in molten natural or filtered wax medium. I use an electric skillet.

For bonus demos, art and more, visit artistsnetwork.com/encaustic-revelation.

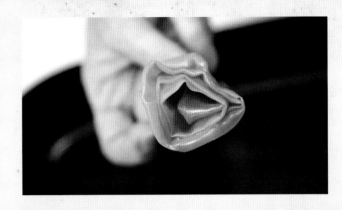

HOT TIP

The petals will collapse in on one another, but don't be concerned about the shape of the rosettes at this point. Allow them to harden and cool completely.

4

Allow the hot wax to drip off the flower, then set each one upright in an egg carton to cool.

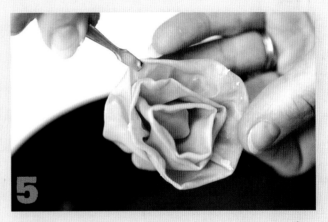

5

When you have dipped all the rosettes, pull apart some of their cooled petals using tweezers or a sharp tool.

6

You will be working with the back side of a cradled wood panel. Prime the cradled panel with wax and allow the natural wood pattern to show through. You may add multiple layers of wax, if you choose; fuse between layers. When cool, protect all the edges with painter's tape.

If you want the wood surface to remain raw, cover the sides, back and outer edges of the cradled panel with painter's tape to protect them from wax drips.

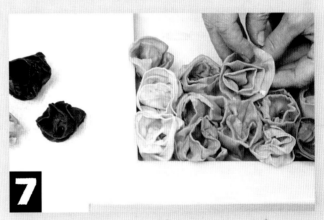

7

Arrange the rosettes in the well of the cradled panel and move them around until you have created a composition that pleases you.

For bonus demos, art and more, visit artistsnetwork.com/encaustic-revelation.

89

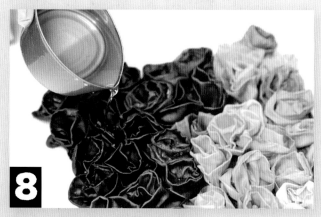

8 Ensure the rosettes are seated in the well of the panel, and pour molten wax into the spaces between the flowers to fuse them to one another. Try not to drip on the flowers, but don't be concerned by their still unattractive shape. They will soon be transformed!

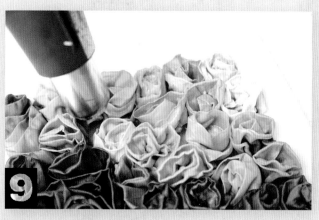

9 Using a heat gun on a low setting (do not use a torch because doing so may ignite the fabric), gently heat each rosette individually. They will puff up with pride beneath the heat!

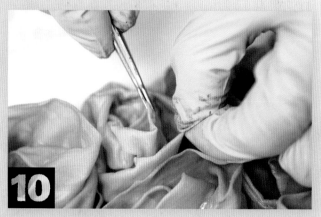

10 Shape and open the warm petals with a metal tool as desired. Reheat the rosettes with the heat gun as needed. Ensure your studio is well ventilated or work outside, and be careful not to burn the fabric. Keep a fire extinguisher on hand and, ideally, place an out-flowing fan beside your work area.

11 Like ravens, I admit to a love of all things shiny. I find that a thin gilded edge is all the roses need for highlight. Their alluring dimensionality is complete, simply by the depth of their sculptural form. Wearing a mask, carefully dip a gloved finger into a jar of Jacquard's Pearl Ex Pigment Powder.

HOT TIP

Most fabrics are not designed to be lightfast under constant exposure to light. As with any fine art, hang your work away from direct light and heat to avoid color fading.

For bonus demos, art and more, visit artistsnetwork.com/encaustic-revelation.

Rub a thin layer of pigment powder over the crisp edge of each flower. Gently fuse with a heat gun.

Remove the painter's tape from your panel. If you have primed the wood, you may wish to rub a small amount of Pearl Ex over this surface. Fuse the powder. Be careful! It is easy to overdo and create a shiny glaze that obstructs the luminescent depth of the waxed wood grain.

HOT IDEAS

- Paint neutral fabric with Jacquard Dye-Na-Flow or dyes to create a custom rainbow of color and variation.
- Try weaving fabric strips before dipping in wax.
- Corrugate a warm wax strip of fabric and fuse to a warm, well-primed encaustic surface.
- Create a textured patchwork quilt of various scraps.

For bonus demos, art and more, visit artistsnetwork.com/encaustic-revelation.

SPINNING FIBER INTO GOLD

Remember the fairy tale of Rumpelstiltskin, who spun straw into gold? Well, the whirling of magical fibers continues today, bringing us new materials that imitate the qualities of fabric, lace and paper, depending on their weight. Synthetic "spunbonded fibers," such as Tyvek, Lutradur and a host of other trade names, are high-density polyethylene fibers that are flashspun and heat-fused. The material is strong and difficult to tear but easy to cut with scissors. Water vapor passes through denser weights, like Tyvek, making them highly breathable, but liquid water cannot because its molecules are too large. These characteristics lend the material to a variety of industrial applications such as housing wrap, hazardous material suits and mailing envelopes. The lacier varieties of spunbonded materials, like Lutradur, have become familiar to us as linings under furniture, interfacing/stabilizer for sewing and landscape fabric, etc.

The versatility of these products, and their unique reactions when heat-distressed, open up worlds of possibility for experimental artists. Because spunbonded materials are strong yet breathable, they provide a perfect partner for wax, which permeates the fibers and adapts to their sometimes flexible, sometimes rigid surfaces.

So put aside the straw and spinning wheel, warm up the wax and reach for new spunbonded fibers to create your unique inventions of gold!

"You will have to experiment and try things out for yourself, and you will not be sure of what you are doing. That's all right. You are feeling your way into the thing."

—Emily Carr

Synthetic Fibers

Spunbonded Tyvek and Lutradur are available in a variety of weights that imitate paper, fabric and lace. Experiment with them all to see what best suits your creative project.

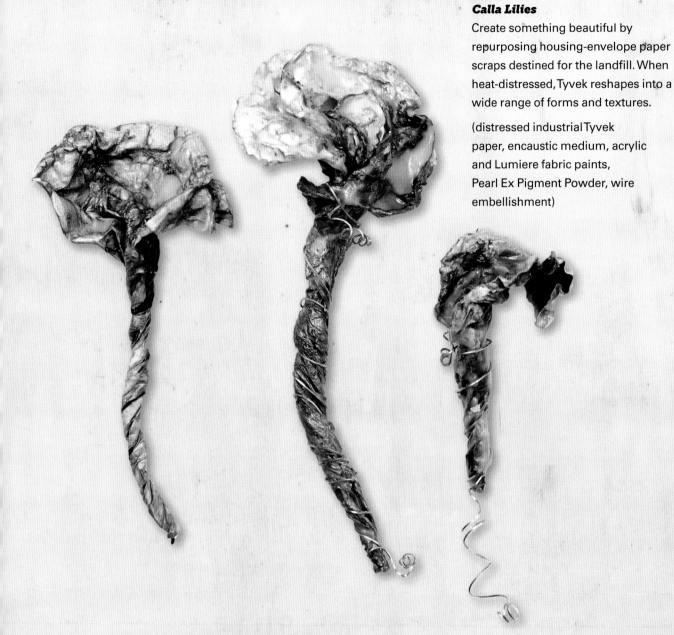

Calla Lilies

Create something beautiful by repurposing housing-envelope paper scraps destined for the landfill. When heat-distressed, Tyvek reshapes into a wide range of forms and textures.

(distressed industrial Tyvek paper, encaustic medium, acrylic and Lumiere fabric paints, Pearl Ex Pigment Powder, wire embellishment)

TYVEK CALLA LILY SCULPTURE

SUPPLIES NEEDED

acrylic or fabric paints	gesso
aluminum foil	heat gun
bristle brush	mask
cotton swabs	Pearl Ex Pigment Powders
damar resin	pliers
decorative wire	protective gloves
electric skillet	scissors
encaustic medium	Tyvek

For bonus demos, art and more, visit artistsnetwork.com/encaustic-revelation.

93

There are so many possibilities when combining spunbonded fibers and hot wax. Here's just one to get you started. Then work up your courage to create inventions all your own! Here's how to create a surprisingly robust floral sculpture with Tyvek paper and beeswax medium.

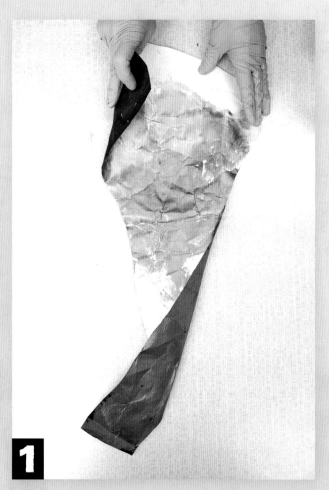

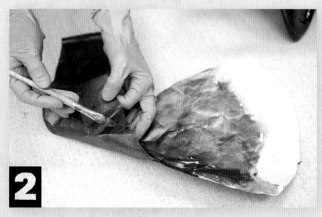

2

Paint the flip side of your paper (i.e., the interior of the petal and stem) with desired colors. Let it dry.

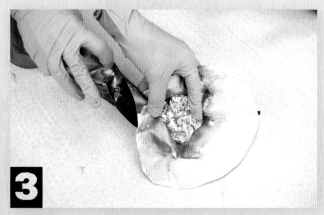

1

Cut a length of Tyvek paper in the shape of a Y, doubling the paper width of your finished petal and tripling the stem size.

If you are using recycled industrial paper, paint the printed side with white or black gesso. If you want the exterior of your flower to have a colored underpainting, paint the exterior of the petal and stem the desired colors using acrylic or fabric paints. My favorite fabric paints are Jacquard's Lumiere metallic or pearlescent paints because of their shiny, luminescent quality.

3

Using household aluminum foil, mold a triangular form around which to shape your Tyvek petal. Wrap the upper portion of your Y-shaped paper around the triangular structure, placing its narrow base at the base of your lily. Twist the paper at the bottom of the petal to hold in place.

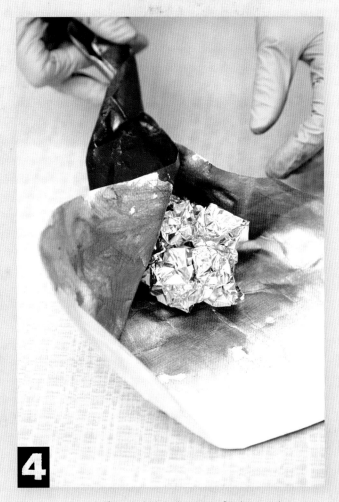

5

Remove the foil form. Twist the upper outer edges of the petal toward the exterior of the flower to form a lip. Reshape your lily as closely as you can to represent the final desired form.

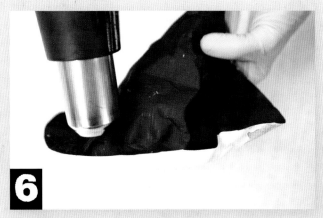

6

Working outdoors with a heat gun on a low setting held 6" (15cm) from your flower, slowly heat the lily petal. It will shrink beneath the heat. Begin slowly and observe how the fibers react under the temperature change. Move your heat gun closer, farther away, or flip paper over to achieve the desired effect. Note that a heat gun held too closely to Tyvek will burn your petal!

4

Flip your paper before twisting the stem further so the colored side faces out. The stem and petal will be loose, but not to worry!

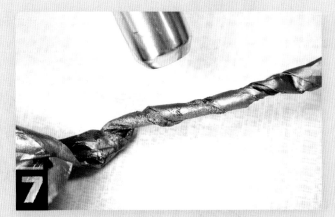

7

Proceed to the stem, slowly heating the twisted Tyvek to the desired shape. It will tighten into itself.

8

Heat beeswax medium in a deep electric skillet. (I prefer a 6:1 ratio of wax to resin for added rigidity.) Ensure you have enough wax in your skillet or heated vessel in which to submerge a good deal of your petal. Turn the petal while submerged and dip the stem to ensure complete wax coverage.

For bonus demos, art and more, visit artistsnetwork.com/encaustic-revelation.

95

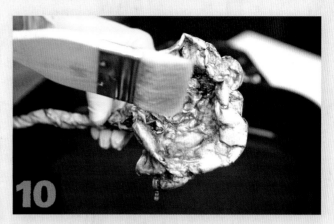

Hold your flower upside down by the stem and allow the excess wax to drip off the petal. Fuse gently with a heat gun, but be careful not to melt the wax off your lily!

Re-dip for added layering if desired. Fuse. You can also brush wax onto specific areas of your lily that you want to build up or that you have difficulty reaching while dipping.

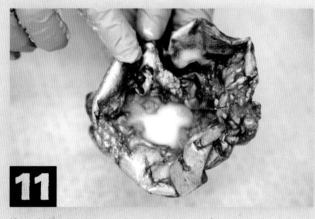

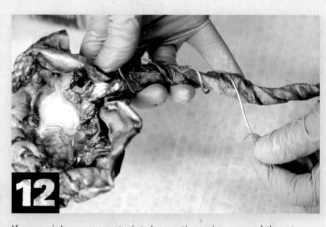

If you'd like a luster to the outer edges of your petal, apply a thin layer of Jacquard's Pearl Ex Pigments. Dip a cotton swab or gloved finger into the jar and rub a small amount of powder into the slightly warm wax. Fuse lightly with a heat gun. Be careful because it is easy to overdo this highlighted effect by applying too much powder!

If you wish, you may twist decorative wire around the stem for added shape, stability and beauty.

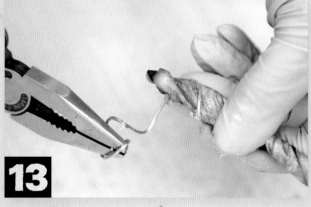

Shape and tie off the wire with pliers.

HOT TIPS

- Always wear a mask and gloves when using powdered pigments.
- Consider creating a bouquet of flower varieties or a series of different sized lilies as wall ornaments.

For bonus demos, art and more, visit artistsnetwork.com/encaustic-revelation.

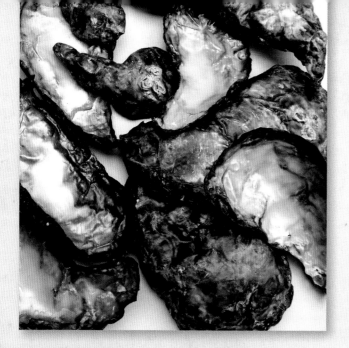

Afterlife

Heat-distressed Tyvek painted with Lumiere and acrylic paints, encaustic medium, Pearl-Ex Pigment.

These larger-than-life mussels measure up to one foot long. Mussel shells are a familiar beach treasure found along Canada's west coast where I live. When alive, mussels are religious emblems of prosperity; when empty of life, they symbolize misfortune and loss. I love how, in their paradoxical wholeness, mussels embody both beauty and ugliness, protection yet vulnerability, life and death -- all of these the many contradictions of human existence.

HOT BONUS

For a bonus demo of working with Lutradur, visit createmixedmedia.com/encaustic-revelation.

RESOURCES

Stitches
stitchesfibreartsupplies.ca | Tyvek, Lutradur, notions, mixed-media supplies

Jacquard
jacquardproducts.com | Dye-Na-Flow paints, Pearl Ex Pigments, Lumiere paints

R&F Handmade Paints
rfpaints.com | pigment sticks

Daniel Smith
danielsmith.com | Lutradur and mixed-media sheets

Dick Blick
dickblick.com | cradled wood artist panels

Repurposed Tyvek, Lutradur and spunbonded fabrics:

- Look in your local hardware or home store for industrial Tyvek (a heavy paper used for house siding), hazardous material suits (fabric-weight Tyvek) and landscape fabric used to block weeds.

- Befriend a construction worker and request left-over scraps of Tyvek destined for the landfill to be repurposed into art!

- The U.S. Postal Service and other express post companies often use Tyvek envelopes for Priority and Express Mail.

- Your local fabric store carries silk, polyester and a variety of weights of interfacing and stabilizers.

- Your local furniture store may use Tyvek or Lutradur underneath furniture; Lutradur can be recycled from the underside of old mattresses.

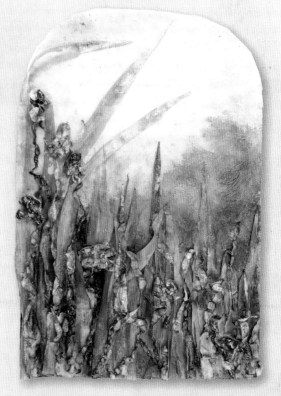

Stained Grass Window

Lutradur painted with Dye-Na-Flow, encaustic medium, Pearl-Ex Pigment.

Lutradur's lacey construction welcomes a tight bond with wax, while maintaining the irresistible luminosity and transparency of beeswax. Illuminated from behind, this combination creates a stained-glass-window effect that invites imaginative possibility.

For bonus demos, art and more, visit artistsnetwork.com/encaustic-revelation.

97

Susan Stover

surface design and encaustic

Fabric and wax have been used together for many centuries and throughout many cultures, from coating fabrics with wax for protection and endurance to creating beautiful patterns with wax and dye. Therefore, it seems a natural combination when you think of using fabric with encaustic. Silk is my favorite fabric to use with encaustic because it absorbs the wax so beautifully, but you may want to try other natural fabrics as well. There are endless options for unique mark-making, layering and patterning when combining surface design techniques on fabric with wax. In this chapter, we will explore contemporary and traditional techniques such as discharge, batik, silk painting and sun printing on silk and how we can use them in encaustic painting.

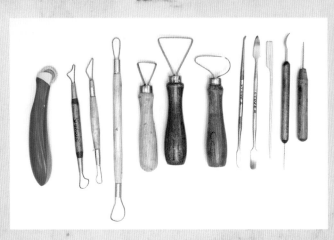

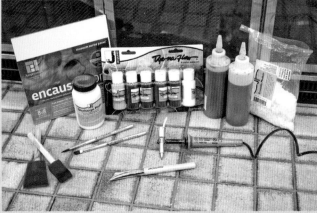

For bonus demos, art and more, visit artistsnetwork.com/encaustic-revelation.

SUPPLIES NEEDED

1" (3cm) and 2" (5cm) foam brushes

cooking oil or blending stick

Discharge Paste

Dye-Na-Flow fabric paint

dyed black silk (best to dye your own using Jacquard's Acid or Procion MX dyes)

encaustic paint and medium

Encausticbords

freezer paper

gloves

iron for wax

newspapers

paper towels

piece of Plexiglas

plastic ice cube tray

scissors

silk habotai, silk organza

soft paint brushes for water-based paints, a few different sizes

spray bottle for water

stencils (plain mylar or acetate)

tjanting tools

wax tools

for making batik stamps: wood blocks, cotton rope, wood glue

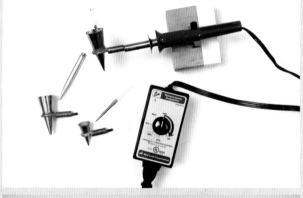

ABOUT THE TOOLS

There are a couple of traditional batik tools that we will be using: a tjanting, which is a drawing implement that has a reservoir for hot wax, a handle and spout; and a tjap, which is a stamping tool used for printing a repeat pattern or image. A tjap is traditionally made of flat, thin pieces of copper or metal that are bent and placed on end to form an intricate design. The copper helps to keep the wax hot as it is applied to the fabric. Our homemade version of a tjap is a stamp made with wood blocks and cotton rope. The cotton rope soaks up the wax and makes multiple prints possible. To make your own, cut pieces of cotton rope and use wood glue to attach the rope to a wood block. It is helpful to attach a smaller block or dowel to the back side as a handle. Experiment with your own mark-making tools. Try sticks, cardboard or kitchen tools!

For bonus demos, art and more, visit artistsnetwork.com/encaustic-revelation.

99

DISCHARGE

Discharge is the process of removing color from a dyed fabric. This is accomplished through a chemical reaction and should be done outside, in a room with good ventilation or while wearing a respirator. The process featured in this demonstration uses Jacquard's Discharge Paste, which is designed for use with natural fabrics.

One of the wonderful things about discharge is that the color that is discharged is sometimes quite different than expected. For this technique I suggest using dyed black silk habotai and organza, but it will work on other dyed fabrics and colors as well. Keep in mind that some dyed colors discharge more effectively than others. It is always a good idea to test a fabric before embarking on a whole project. For the purposes of this demonstration, I have pre-dyed the fabric with Jacquard's Procion MX dyes.

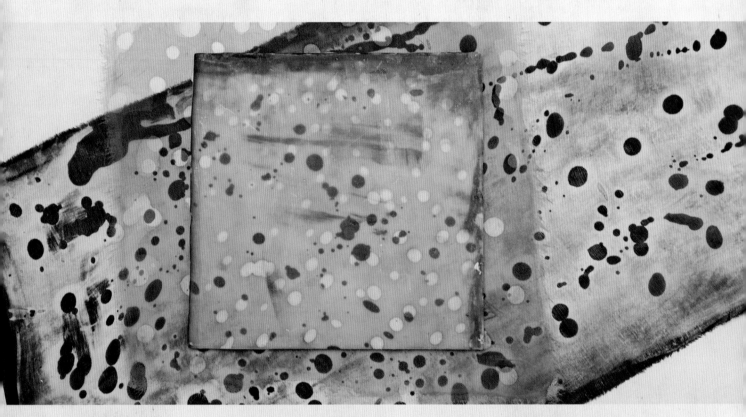

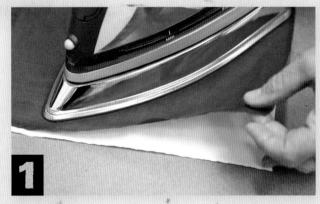

1

With the shiny side of the freezer paper up, iron your piece of silk onto the freezer paper. Use a dry iron, no steam. This will help to stabilize the fabric as you are working on it.

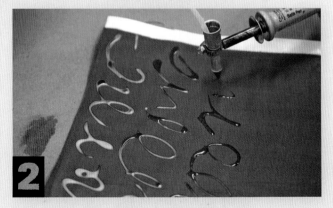

2

Apply encaustic medium using a brush, tjanting or tjap.

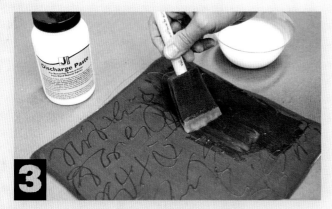

3

After the wax has cooled, use a foam brush to spread Discharge Paste over the fabric. Let it dry completely.

4

Pull the fabric from the freezer paper.

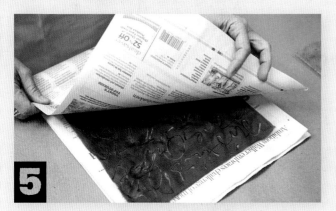

5

Place the fabric between sheets of newspaper.

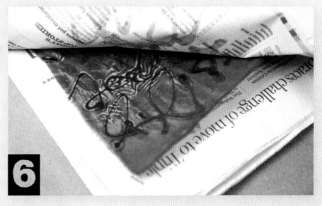

6

Iron the fabric through the newspaper. A steam iron is best for the discharge process.

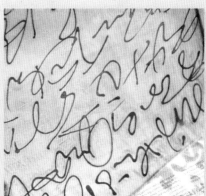

7

Continue to iron until as much of the wax as possible has been removed from the fabric. As you apply heat and steam, the color of the fabric will gradually change. All kinds of subtle color variations are possible by varying the application of Discharge Paste and the amount of steam and heat. Remove the fabric from the newspaper. To remove any Discharge Paste residue, rinse your fabric with a mild soap and dry.

For bonus demos, art and more, visit artistsnetwork.com/encaustic-revelation.

BATIK AND SILK PAINTING

Batik is the process of applying wax to a fabric and then dyeing it. Successive layers of wax and dye can be applied to build up layers of pattern or imagery. Silk painting, traditionally done in the serti method, involves laying down lines of wax to enclose shapes on a piece of fabric. Dye is then applied within the closed shapes. In this demonstration we will experiment with both of these approaches.

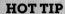

HOT TIP
It helps to keep your stamps warm on the palette, griddle or shallow pan.

1 With the shiny side of the freezer paper up, iron your piece of silk onto the freezer paper. Use a dry iron, no steam. This will help to stabilize the fabric as you are working on it.

2 Apply encaustic medium using a brush, tjanting or tjap.

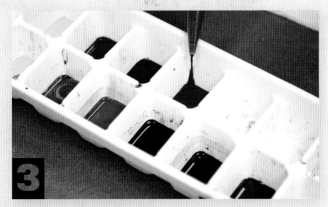

3

In the plastic ice cube tray, mix colors of Jacquard's Dye-Na-Flow. To make pastels, the colors can be diluted with water. (Dye-Na-Flow is a water-based fabric paint that flows like a dye.)

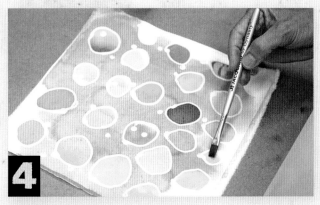

4

Paint the silk. You may choose to do multicolor washes over the whole fabric or more-detailed filling in of shapes. Let the fabric and dye dry completely.

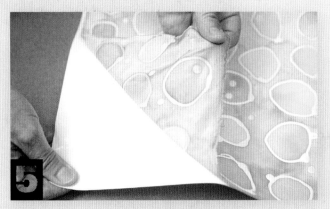

5

Pull the fabric from the freezer paper.

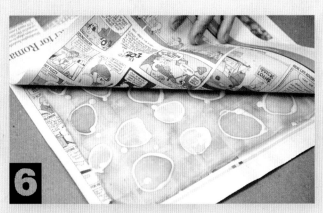

6

Place the fabric between sheets of newspaper.

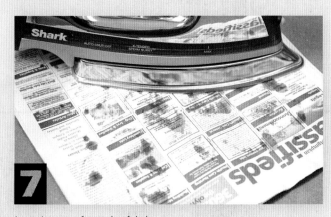

7

Iron the wax from the fabric.

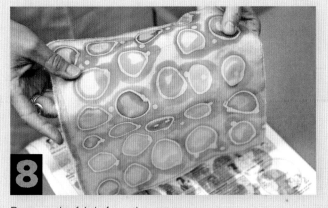

8

Remove the fabric from the newspaper.

HOT TIP

You don't need to iron out the wax completely, but I find that it is easier to embed the fabric in encaustic later if it isn't all bumpy with wax.

For bonus demos, art and more, visit artistsnetwork.com/encaustic-revelation.

SUN PRINTING

The technique of sun printing is easy and fun and provides fantastic results. All you need is a sunny day.

1 Place your piece of silk onto the Plexiglas and spray with water so the silk sticks to it.

2 Using a watered-down solution of one or more colors of Dye-Na-Flow, saturate the silk. Don't worry if the color seems too pale. It will darken in the process.

3 Before the silk has time to dry at all, place stencils on top of the silk and set it in the sun. You can use hand-cut mylar, commercial stencils or found objects.

4 As the silk dries in the sun, the Dye-Na-Flow migrates to the areas that are not covered by the stencil. Remove the stencils when the fabric and paint have dried.

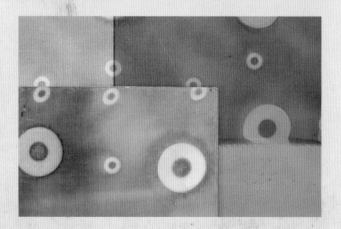

HOT TIP

Looking for stencil ideas? Take a look around your home—the kitchen and basement are great places to start! For example, metal washers can be used to make a great polka-dot pattern.

For bonus demos, art and more, visit artistsnetwork.com/encaustic-revelation.

INCORPORATING YOUR SURFACE-DESIGNED FABRIC INTO ENCAUSTIC PAINTINGS

Now comes the fun part, as if you aren't having fun already! There are limitless possibilities for surface-design techniques when combined with encaustic. I hope these demonstrations start the wheels turning and get you thinking about how you can bring your own ideas of fabric and wax together.

TO APPLY FABRIC OVER A WHOLE PAINTING:

1 Start with a few layers of fused encaustic medium or paint on your bord. Press a piece of fabric that is slightly larger than the bord onto the smooth, warm surface. (Here I've painted a color onto a bord. If you decide to do this, consider how the paint color might affect the color of your fabric.)

2 Turn the bord over and cut along the edge of the bord with a craft knife to remove any excess fabric.

HOT TIP
You can prevent air bubbles underneath the fabric by making sure your encaustic surface is smooth.

3 Brush a layer of clear medium over the fabric.

4 Use a pottery tool to remove any bumps or unwanted texture in the wax.

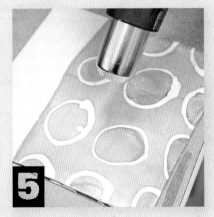

5 Fuse.

For bonus demos, art and more, visit artistsnetwork.com/encaustic-revelation.

105

MARK-MAKING

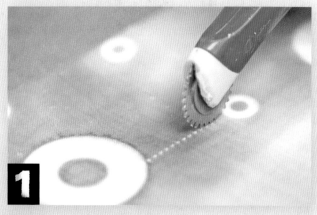

Adhere a piece of fabric to a bord by embedding it between layers of wax. Then use a variety of household tools to make marks in the wax.

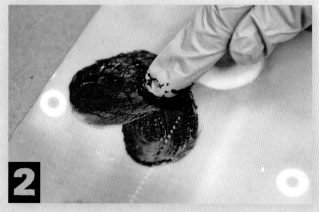

Apply a bit of pigment or oil stick to the surface of the wax. Wear gloves to keep the pigment or oil off of your skin.

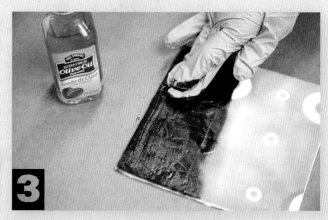

Rub the pigment into your handmade marks.

To remove excess pigment, wipe the surface with a tiny bit of cooking oil or blending stick and a paper towel.

"What art offers is space—
a certain breathing room for the spirit."

—John Updike

For bonus demos, art and more, visit artistsnetwork.com/encaustic-revelation.

EMBELLISHING WITH SURFACE DESIGN TOOLS

The tools we used to create the fabrics can also be used with encaustic paint.

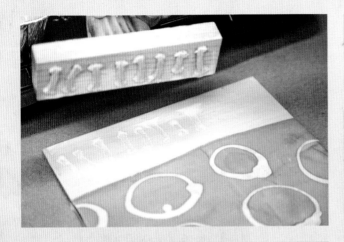

Dip a homemade stamp into a colored wax and apply directly to the painting.

Draw or make dots with a tjanting tool.

RESOURCES

Jacquard
jacquardproducts.com | encaustic medium, beeswax, damar resin, Dye-Na-Flow paint, tjanting tools, Discharge Paste, Procion MX dyes, acid dyes and other fabric paints and dyes, silk and fabric by the yard

R&F Handmade Paints
rfpaints.com | encaustic paint, oil sticks, blending sticks

Enkaustikos
encausticpaints.com | encaustic paint

Ampersand Art Supply
ampersandart.com | Encausticbords, cradled panels

For bonus demos, art and more, visit artistsnetwork.com/encaustic-revelation.

107

Sample Painting
Encaustic painting with dis-
charged black silk habotai.

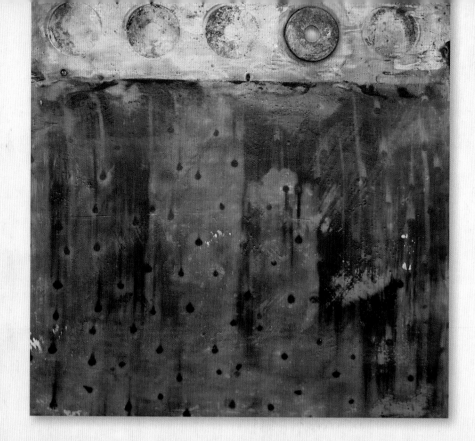

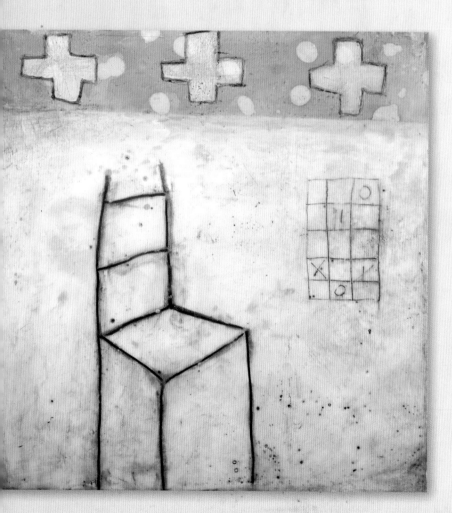

Waiting for a Sign
Encaustic painting with Dye-
Na-Flow painted silk organza.

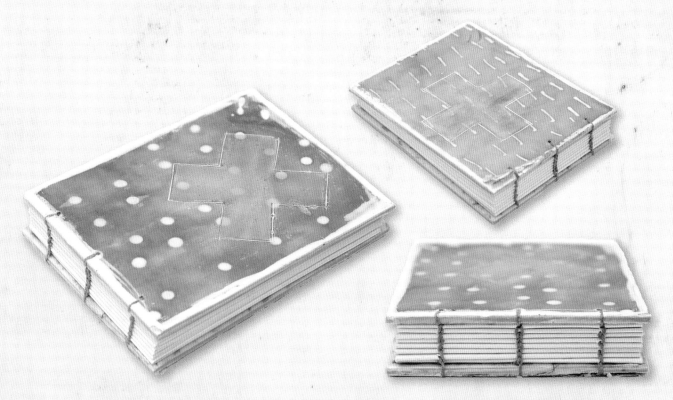

Encaustic Blank Books
Covers feature painted silk fabrics, pastels and oil sticks.

Untitled
Encaustic painting with embedded discharged black silk habotai.

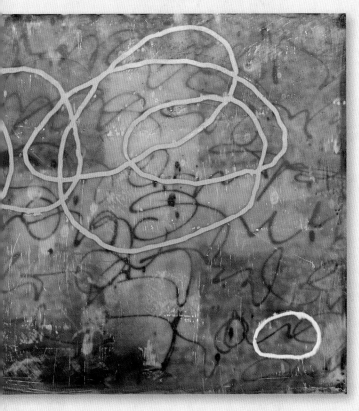

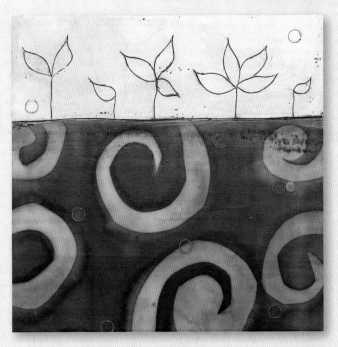

Sample Painting
Encaustic painting with sun-printed silk habotai.

For bonus demos, art and more, visit artistsnetwork.com/encaustic-revelation.

109

encausticamp participant gallery

This is the question I've been answering for a few years now, since an unassuming day in 2007 when I decided to respond to my first "what if?"

And from it, among other things, came Encausti-Camp, an opportunity for others to gather together and experience amazing art, connections, influence and inspiration—and a whole heap of fun and beautiful scenery!

I hope the preceding chapters have proven undeniably that EncaustiCamp is an amazing place to experience the dynamic nature of this delicious, ancient art of encaustic painting. But if you are still waffling in your belief, then let this gallery space do the job!

Here you find the awe-inspiring investments of talent, skill, beauty and honesty from EncaustiCamp 2013 attendees—or as I like to call them EncaustiCamp lifers. Once you are in, you're in for life. Encaustic is that good; but what's more, EncaustiCamp is that good for inspiring you to more.

I wish the full attendance of EncaustiCamp could be represented here, but alas, if we'd done that, there would be no instructor chapters! All the work was phenomenal, as the final night's exhibit attested.

Even further though, the dynamic nature of encaustic shows up. The sheer volume of diversity of style that prevails, despite having been instructed in the same techniques, is remarkable, and this participant gallery speaks to the truth of this. Encaustic is all-inclusive and EncaustiCamp is bringing it on!

Heaps of gratitude to the artists represented here, but not to be left out is immense gratitude for all those at EncaustiCamp every year, past and future. Thank you for proving many of my "what ifs" true. It wouldn't be without you! The beautiful work you've created is testimony.

Have a go!

—Trish

- While every effort has been made to represent the artists' works, names and contact information correctly, human error must be accounted for! Should this be in need here, I apologize for any errors in representation; there's a lot of work produced at EncaustiCamp!

- Also please keep in mind that all art shared here is participant/student art and may or may not be in its finished, final form.

For bonus demos, art and more, visit artistsnetwork.com/encaustic-revelation.

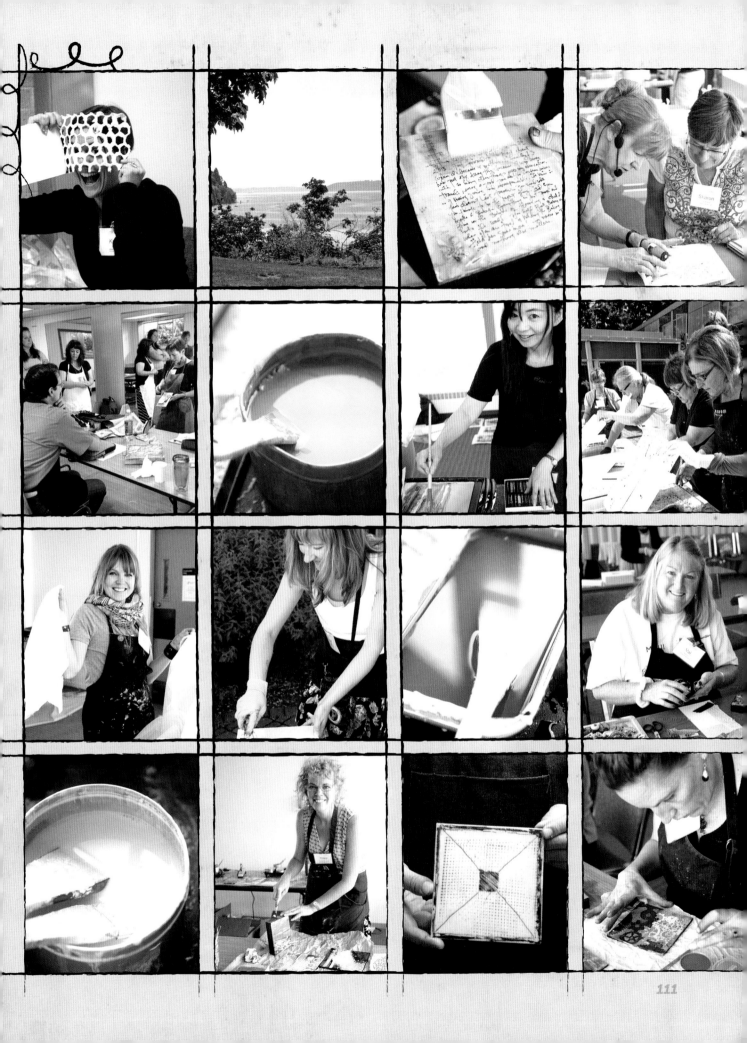

Title: Untitled | Tracy Proctor | Calgary, Alberta
Website: tracyproctor.com; Facebook: tracyproctorkelly

EncaustiCamp is about the cultural experience—artists coming together from all walks of life to exchange knowledge and share a passion for encaustic in breathtaking surroundings. The most memorable part of attending another encaustic conference was reconnecting for a reunion with my "E-Camp family." I have been to several encaustic conferences in Massachusetts and Santa Fe and nothing compares to EncaustiCamp. The workshops that I teach at home are unique because of the abundance of knowledge that was shared by both students and instructors at E-Camp.

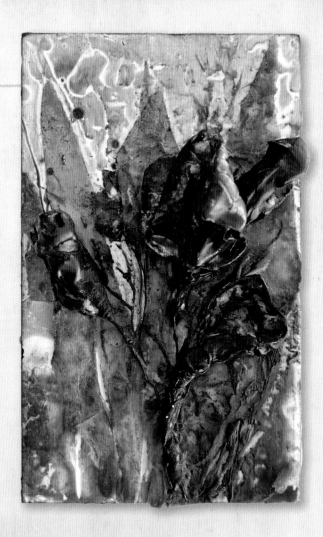

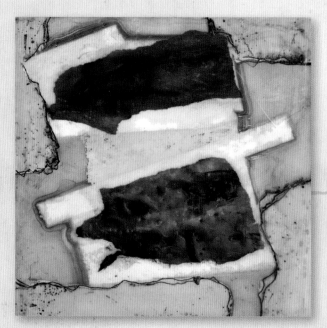

Title: Untitled | Stephen Workman | St. Paul, Minnesota
Website: workman-studio.tumblr.com

All three EncaustiCamps have given me a strong foundation in mixed-media encaustics. I now teach encaustics as a professor and workshop leader because of my experiences at EncaustiCamp.

Title: Friend or Foe? | Anne Kneller | Brookline, Massachusetts
E-mail: knellertopia@gmail.com

Trish provided large vats of "fragrant" Indigo dye into which we immersed Encausticbord panels. Clear wax resist revealed the white board, giving some nice contrast to the bold blue. I scrawled with Micron pen and embedded inkjet tissue photos of insects. There are just four layers of encaustic medium here. India ink and copper leaf embellish the top and final layer. E-Camp Seattle is all about love and creativity, friendship and experimentation—a valuable and validating experience like no other.

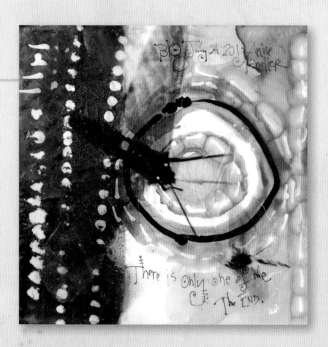

Title: Blue Indigo | Carrie Ann Knupp | Eustis, Florida
Website: encausticguru.com

This piece features experimentation with Indigo ink, pigmented wax, oil stick and gold foil. I first applied spackle, inserted paint stir sticks and then lifted them. Then came an Indigo bath, and finally I applied wax, gold foil and oil stick.

Encaustic was started by the Greeks more than 4,000 years ago, and because my daughter and I are of Greek descent, we are drawn to this media in ways not even we can understand. Patricia's EncaustiCamp enabled my daughter and me to connect in a very precious way—through our love of art and our love of encaustics.

Patricia was the guiding light that brought us together as fellow artists. She made learning fun, as did all the teachers.

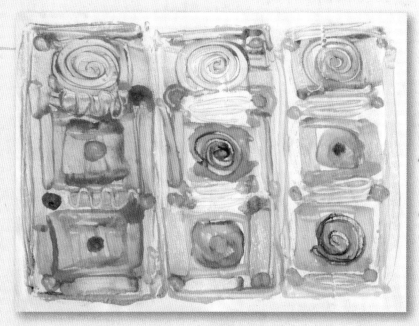

Title: Round Pegs in Square Holes |
Sharon Lynn Williams | Calgary, Alberta
Website: sharonlynnwilliams.com;
sharonlynnwilliams.blogspot.com

This painting was done on the Roland HOTbox in Judy Wise's monoprinting class. It was wonderful to work on the hotbox in order to work large. This painting measures 16" × 22" (41cm × 56cm) on Sumi paper, using R&F encaustic paint. The pure colors of the paint were a delight to slide onto the very absorbent paper. EncaustiCamp was a dream come true, with expert, caring instructors and a very knowledgeable and sharing student body.

Title: Untitled | Kristina Trudell | Kirkland, Washington
Facebook: Kristina Honn-Trudell

EncaustiCamp is all about connections, enthusiasm, inspiration, honesty, encouragement and trust, with the common thread being a love of painting with wax. Crystal's explanation for collecting papers as collecting bits and pieces of people's lives and honoring them through her artwork has made me look at the ephemera around me in a whole new light. I loved going to camp as a child. Not much has changed. I look forward to EncaustiCamp every year!

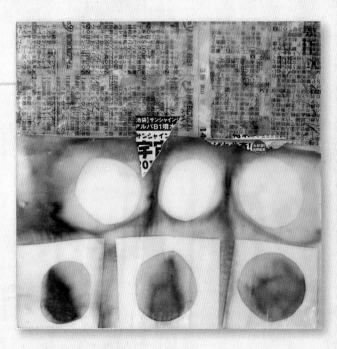

Title: *Illumination* | Carol Retsch-Bogart |
Chapel Hill, North Carolina
Website: carolretschbogart.com

Mixed media excites me, and this piece is a true example. It combines several techniques: encaustic painting utilizing pigmented medium together with printmaking on silk and collage with Japanese newspaper. The text illuminates by telling a story, as does the transparency of beeswax, which allows the light to come through.

EncaustiCamp provided a wonderful opportunity to dabble in many ways with the extraordinary and diverse medium of encaustic.

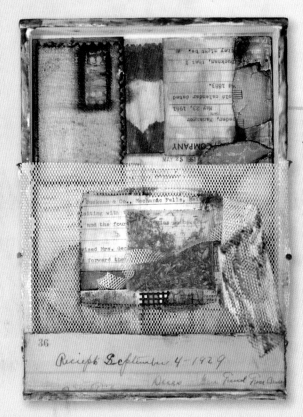

Title: *Seattle Viewfinder* | Brenda Tassava
Indianapolis, Indiana
Website: encaustication.com; Facebook: encaustication

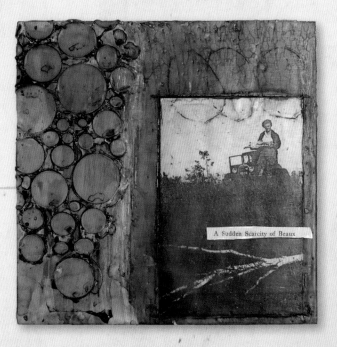

Title: *Scarcity of Beaux* | Susan Metcalfe |
San Antonio, Texas
Website: halcyondays-susan.blogspot.com

This was my first piece incorporating plaster, Indigo dye, and texturing techniques learned in Trish's class. The photo of my no-nonsense grandmother has always been a favorite of mine, and it just seemed to work with the organic feel of the piece.

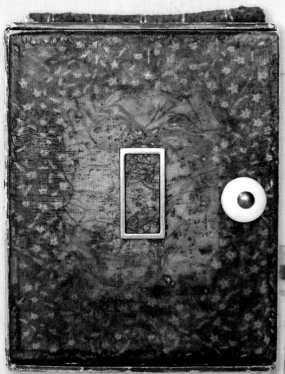

Title: The Collector | Doug Loates | Tacoma, Washington
Website: loatesart.com
EncaustiCamp was a life-changing experience! I was exposed to exciting techniques in a supportive learning environment! Not to be missed!

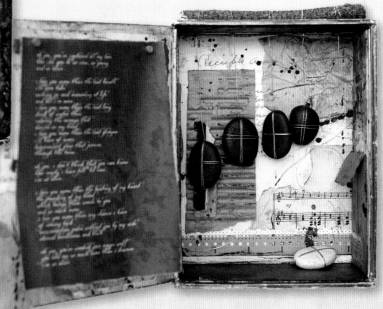

Title: Before It Happens #1 | Misako Oba
Website: misakooba.com; blog: misakooba.wordpress. com;
Facebook: MisakoArt; E-mail: contactmisako@gmail.com
Blue has been a signature color in a number of my series for some years now. I always feel excited to explore different types, tones and textures of blue depending on the individual concept of each work. I create from my soul, exploring my emotions along life's journey. For this piece I applied indigo blue dye directly onto the board before anything else. It adds additional depth and variation to my encaustic mixed-media creation.

For bonus demos, art and more, visit artistsnetwork.com/encaustic-revelation.

115

Title: Untitled | Carol Myers | Watervliet, Michigan
Website: carollmyers.com

Trish has created an incredible combination of art/creativity/ friendship/inspiration/joy that is far more wonderful than any other camp or group experience I have ever encountered. Instructors and participants share meals, lodging, art, ideas, fun and free time, creating a close, inspirational group experience that has me coming back year after year. Such a treasure!

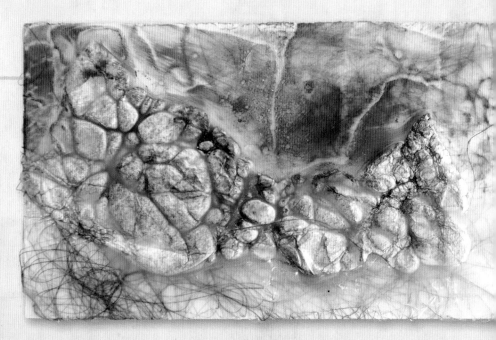

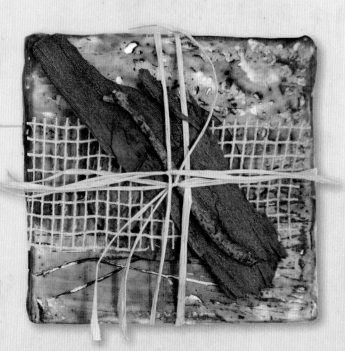

Title: Songs You Should Never Forget | Patricia Peters | Grande Prairie, Alberta
Website: freshpaintstudio.blogspot.com

This is a nostalgic piece with vintage papers, rusted wire, nails, encaustic paint and a delightful piece of bookbinding that fans out.

It was a tremendous experience to work elbow to elbow and see how others finesse the fickle hot medium. The sharing and caring were exceptional at EncaustiCamp!

Title: Textured Block | Jean K. Brown | Elgin, Illinois
Facebook: artism

As a beginner in the exploration of encaustic wax as a painting medium, EncaustiCamp was an invaluable experience. To see the many ways our talented instructors put their own inter- pretation on combining materials opened my mind to many possibilities that I still consider every time I'm in the studio.

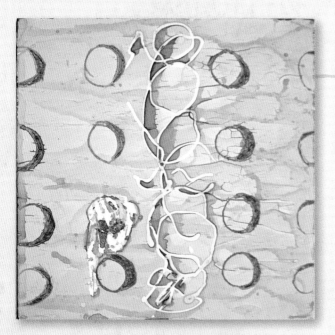

Title: Untitled | Laurie Hunt | Rochester Hills, Michigan

My goals when attending EncaustiCamp are to try and learn. This piece is the result of that practice in a class on using dyes with wax and other mediums. I coated a board with Venetian plaster, let it dry, incised the circles, drizzled wax, then dipped it in a bath of dye. I then used this piece along with others to see how the various mediums, including encaustic, responded to the different types and color of dyes.

Title: Guardian | Melanie Wade Leslie | Spring, Texas
Website: melanieleslie.com

This encaustic piece incorporates various collage elements, one of which is a torn scrap from a relief print that I printed a while ago. I love rethinking and repurposing prints like these into new art forms.

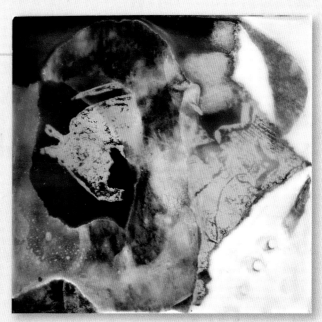

Title: Work in Progress | Kari Little | Calgary, Alberta

EncaustiCamp is more than five days of artful bliss. It is an experience that encourages each attendee to elevate their own art and perception of self. The life-long relationships that are developed at camp are both personal and professional. These relationships continue to provide me (and others!) with inspiration, confidence and tools to grow as an artist … long after the last workshop!

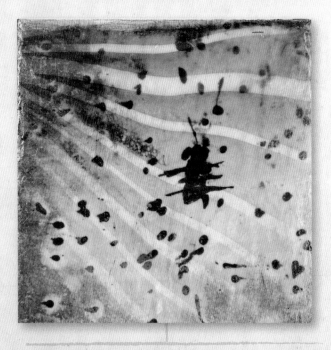

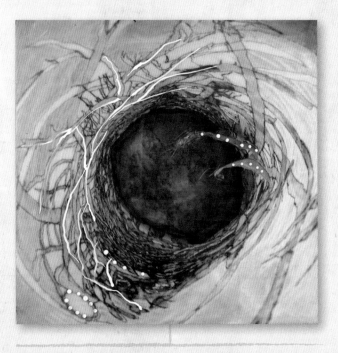

Title: Asian Bee | Allanah Ashlie | West Seattle, Washington
E-mail: aashlie@gmail.com; Facebook: Alannah Ashlie
The piece consists of encaustics, layers of discharge and sun-painted silks and is edged with metallic gold. This piece was completed in Sue Stover's class at EncaustiCamp 2013, where I learned about dying silk and incorporating it with wax.

Title: Encaustic Nest | Anni Hunt | British Columbia
Website: annihunt.com; Facebook: TextileArtistAnniHunt
The piece is in a series I have been working on about home. The nest is featuring prominently at present.

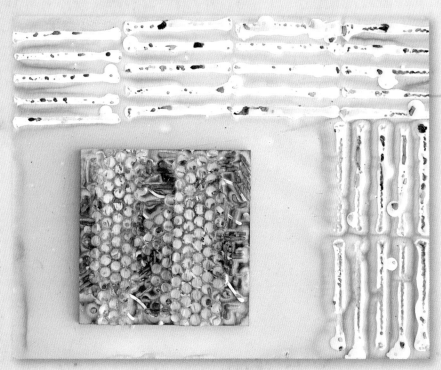

Title: Untitled | Iris Duarte
Clovis, California
Website: idoarty.com; E-mail:
irisduarte9@ gmail.com
EncaustiCamp is an extremely invigorating and delightful place to learn, grow and meet others who are interested in the artistic experience. Patricia Seggebruch and her crew of teachers are amazing, inspirational and fun. It is an experience that will leave you wanting more and waiting to come back to see friends and teachers and continue one's artistic exploration.

For bonus demos, art and more, visit artistsnetwork.com/encaustic-revelation.

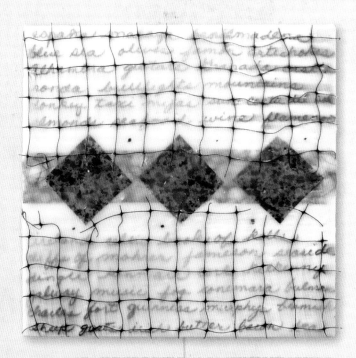

Title: Untitled | Rhonda Chilton | Pinetop, Arizona
Facebook: Rhonda Chilton

My piece represents a 2012 trip to Ireland and Spain to celebrate thirty years of marriage. My EncaustiCamp experience was wonderful! Where else do you get to practice art, learn from great teachers, while having breakfast, lunch and dinner prepared and served for you with no dress code required. I can't think of anything better!

Title: Blue Illusion | Elizabeth Bellmer |
Edmonds, Washington
E-mail: elizbell@comcast.net

This piece was crafted incorporating encaustic medium, indigo dye, stencils and pan pastels. I enjoy using art as an opportunity to relax and indulge my creativity. My work has included mixed media, encaustic, acrylic painting and paper-crafting. The opportunity to attend EncaustiCamp has been an exciting, fun and educational experience. Best of all, I've been blessed by making life-long friends.

Title: Backwater | Debbie Supplitt |
Vancouver, Washington
E-mail: supplitt@comcast.net

Backwater was created to depict the essence and aesthetic of the bayou. (Process: Dying 8" × 8" [20cm × 20cm] substrate black, Venetian plaster was applied, and sculpted areas removed. Alternating layers of clear and light blue encaustic medium were fused into the relief-sculpted surface. Black foil highlights the surface area.)

EncaustiCamp provides the encaustic artist the opportunity to create alongside other encaustic artists. During breakout sessions, artists learn new techniques, discover new tools, apply novel concepts, but mostly establish a common ground for creating magic with friends.

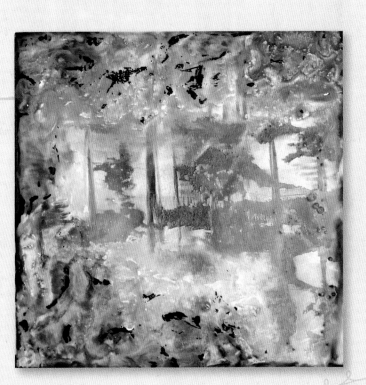

For bonus demos, art and more, visit artistsnetwork.com/encaustic-revelation.

119

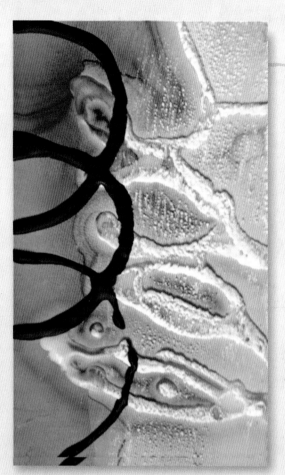

Title: Spontaneous Kiss | Tracy Felix Fraker |
Website: tracykayfraker.net; artspotedmonds.com

I adore working with Patricia and the amazing artists she gathers around her. Trish is exceedingly generous, talented and hardworking. Because of her influence, my opportunities as an artist and business-person in the arts have flourished.

I am now a vendor at EncaustiCamp with my new art supply store ARTspot … and even teaching _Renegade Encaustics!_ at my own studio.

Also, the connections made with other students there have created ongoing collaborations that benefit us all beyond the week we spend together at EncaustiCamp.

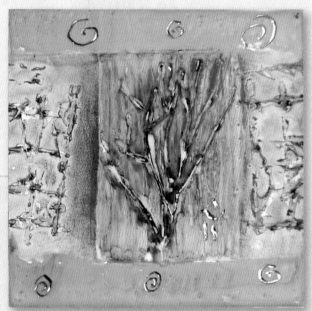

Title: Untitled | Valeré Skidmore | Cheyenne, Wyoming
E-mail: skidmv@live.com

EncaustiCamp is all about learning, sharing, establishing friendships and embracing your inner wax artist. Patricia has an incredible talent and has put together a one-of-a-kind yearly event in EncaustiCamp. The teachers and classes are truly a unique experience!

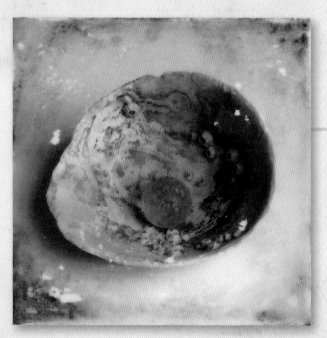

Title: Three Tree Point Shell Stack #1 | Maureen Hoffmann |
Burien, Washington
Website: redredcircle.com

To be surrounded by other folks in the midst of creation ignites the brain with sparks of ideas. EncaustiCamp provides such ignition and inspiration, in addition to new, creative friendships.

For bonus demos, art and more, visit artistsnetwork.com/encaustic-revelation.

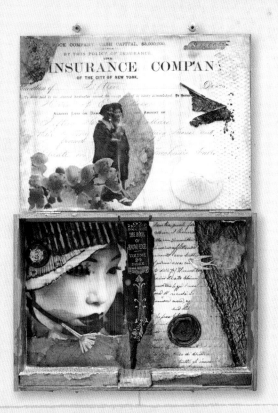

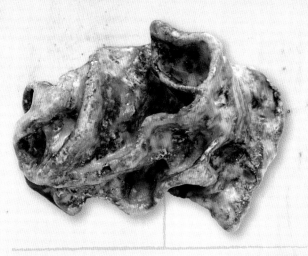

Title: *Moon Rock* | Kristi Knupp | Venice Beach, California
Website: *evoke-emotion.com;*
E-mail: *KristiKnupp@gmail.com*
This is my very first 3-D encaustics piece. I loved Michelle Belto's class so much! She really opened my eyes to a new way of creating art. Thank you, Michelle!

Title: *Insurance* | Betti "BZ" Zucker | New York, New York
Blog: *bettisbeehive.blogspot.com*
The moment I walked into camp, the facility and students made me feel welcomed. I walked away not only with new techniques but with the confidence that I am an artist that can take that next step of recognition.

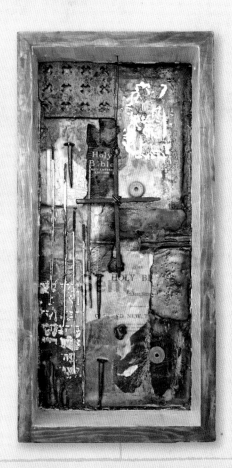

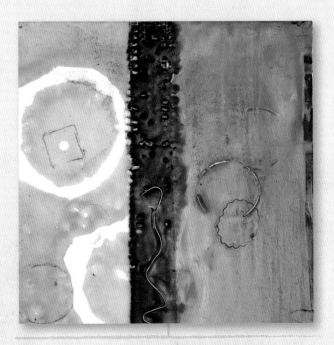

Title: *Indigo Twilight* | Jane Evasiuk | Whitecourt, Alberta
With thanks to Trish for totally hooking me on waxy art in 2011! Her EncaustiCamp was the ultimate art experience. Learning from so many talented encaustic artists—both instructors and participants—and trying amazing and different techniques was so inspiring. As a beginner, I am excited to know there are endless directions to explore in developing my own encaustic style.

Title: *Untitled* | Jennifer Martin | Cocoa, Florida
Website: *micorazonart.com*
My faith and my art seem to find their way into my paintings a great deal in the last two years … and these paintings I feel are my best work as a artist. These paintings come from the deepest part of my soul and show true self. I hope you enjoy my "faith in a box," which was inspired by the many times in my life that I have put my faith in a box and only called upon God when I needed him … not realizing he was always with me …

AMANDA JOLLEY's career path as an accountant compelled her to search for greater meaning in life. After leaving corporate accounting in the mid-1990s, she began exploring mixed media and found great satisfaction in collage, whether on canvas, in her soldered jewelry or in her altered books and art journals. Drawn to the depth and luminous characteristics of wax, her creative journey settled in and found a home with encaustic painting. Since her introduction to the world of encaustic, she has been experimenting with form and texture, often incorporating her collage elements and origami structures into the wax. Amanda has been published in *Cloth Paper Scissors* and regularly shows her paintings in Kansas City. Amanda has a passion for sharing the healing properties of art with a distinct segment of the Kansas City population, exploited women, and spends much of her time planning projects to promote healing in addition to teaching encaustic, soldering and art-journaling classes in the Kansas City area. *amandajolley.com*

MICHELLE BELTO is a multifaceted artist and teacher. Her work as a performer, educator and visual artist spans more than thirty years, three continents and thirteen publications. She divides her time between her two passions: teaching encaustic painting and creating studio art with an emphasis on handmade paper and wax. Through North Light Books, Michelle authored the book *Wax and Paper Workshop: Techniques for Combining Encaustic Paint and Handmade Paper* and produced two videos, *In the Encaustic Studio: Basic Mixed Media Techniques and In the Encaustic Studio: Advanced Mixed Media Techniques*. She currently is an adjunct faculty member at the Southwest School of Art in San Antonio, Texas, and conducts workshops in paper and wax nationally and internationally. Michelle is a dynamic and energizing teacher who is generous with her information and organized with its presentation. *michellebelto.com*

SUSAN STOVER received an MFA from California College of the Arts in Oakland, California, and a BFA from Miami University in Oxford, Ohio, with both degrees concentrating in textiles and painting. She has been a faculty member at UC Davis, lab technician at CCA and spent ten years at Jacquard Products, a manufacturer of textile pigments and dyes. Sue has presented at CHA and NAMTA trade shows and the International Encaustic Artists conference, and teaches workshops nationally and internationally. Her paintings are in many private collections, and her work was included in *Wax and Paper Workshop* by Michelle Belto (North Light Books) and *Gathering Clouds: A Magazine of Contemporary Art*. Susan maintains her studio in the northern California wine country where she resides with her husband and daughter. *susanstover.com | facebook.com/susanstoverfineart*

KATHRYN BEVIER is inspired by her surroundings: the wooded lots and expansive farmland near her home and the city scenes near her studio and office. Her art is influenced by the way shapes merge and colors coordinate. "There always seems to be a balance, and I am drawn to that," she says.

Kathryn earned her BFA at Lyme Academy College of Fine Arts. She is the General Manager and head of education for Enkaustikos Wax Art Supplies. She has traveled extensively throughout the U.S. and Canada for Enkaustikos providing learning opportunities in a variety of arenas, including the National Art Materials Trade Association, I.E.A EncaustiCon, EncaustiCamp, Rochester Institute of Technology, College Art Association, The Encaustic Conference, Savannah College of Art and Design, and various regional art expositions. Kathryn offers ongoing workshops in her private studio and is active in the Rochester arts community through her involvement with many arts organizations and local colleges and public schools.

Kathryn lives in Rochester, New York, with her husband, daughter and grandson. *kathrynbevier.blogspot.com*

CRYSTAL NEUBAUER is a mixed-media artist drawn to the broken, cast-out and overlooked items of the past. She sees beauty in the mundane, brings new life to forgotten objects and finds the process of salvaging old materials and creating new art to be therapeutic and healing. As her work evolves, a more complete understanding of why she does what she does and why she chooses to use materials that others see as trash comes to light:

It's about seeing something
beautiful in the discarded
About giving new life to what
has been broken and cast out
It's about seeing worth in what
has been deemed worthless
And value in the valueless
Ultimately it's about humanity
And redemption
And love

Find Crystal's work online at her website, *crystalneubauer.com,* and blog, *otherpeoplesflowers. blogspot.com,* and watch for her upcoming book about the art of collage from North Light Books in 2015.

JUDY WISE is an Oregon painter, writer and teacher whose work has been published over several decades in books and periodicals, on greeting cards, textiles, educational materials, calendars and in the gift industry. She is prolific and inventive, keeping daily journals of her writing and art since childhood. Through F&W Media, Judy co-authored the book, *Plaster Studio: Mixed Media Techniques for Painting, Casting and Sculpting* and has published a series of eBooks on Hot Wax, Cold Wax, Mixed Media Journaling, Plaster and Painting Faces. In 2012 she was an artist in residence at Can Serrat near Barcelona, Spain and has taught in workshops across the U. S. and in Australia and Mexico. *judywise.com | judywise.blogspot.com*

SHARY BARTLETT is a fine arts instructor at Capilano University and Langara College in Vancouver, Canada. She has loved beauty and making art since her earliest days when she pushed her chubby fingers into children's scissors and cut pretty pictures out of magazines. Since then, Shary has tried her hand at almost every fine art and craft technique she encountered, always excited to explore something new. Unable to commit herself to just one art form, she is an incurable and passionate mixed-media artist whose body of work includes encaustic, collage, acrylic, fiber arts, altered photographic prints and sculptural assemblage. She loves to travel and teaches international art workshops in North America and Asia. Shary holds a master's degree from Carleton University, specializing in Canadian arts and cultural history. Her work has been exhibited in solo and group exhibitions, and her community public art commissions are on display at the Vancouver Parks Board, the Vancouver Public Library and the Vancouver Foundation. Her work is held in private collections throughout Canada and the U.S.

Shary lives with her husband and two children in Vancouver. You will find her social media links through her website, *sharybartlett.com*.

BRIDGETTE GUERZON MILLS'S mixed-media work incorporates a variety of materials, including photography, oils, acrylics and encaustic. Her mixed-media paintings incorporate moments captured by her photographs with the richness of paint, creating a bridge between two worlds—the real and the reconstructed. She builds up layers of paint with photo transfers, as well as collage, to create depth in both form and meaning. The canvas becomes a multilayered surface that speaks to both the visual and tactile senses.

Bridgette's artwork, artist books and journals have been published in magazines and books, and her work has been collected in the United States and internationally. She has exhibited her work nationally and abroad. She has taught her encaustic and book art workshops at EncaustiCamp, Lesley Riley's Red Thread Retreat in Maryland and at various studios and schools in Illinois and Washington. She currently resides in Maryland with her husband, two children and dog. Her work can be seen online at *guerzonmills.com* and *bgmartjournal.blogspot.com*.

For bonus demos, art and more, visit artistsnetwork.com/encaustic-revelation.

123

My life began again in 2007, although I do not fail to miss the connection points and continuous unfolding throughout my years prior. Not coincidentally my first book, *Encaustic Workshop*, was contracted that spring. Call it a turning point—or the point at which I can look back and pin the turning onto, if asked to pin.

I always wanted to teach. I attended the University of Colorado (go Buffs!) intent on getting an English degree to this end. Alas, I discovered I am just really, really good at reading. I could not stomach standing in front of a classroom of nearly blank, bland faces all the days of my life.

Yet fifteen years later I found myself, four boys underfoot, painting and experimenting with color and texture and desiring once again to teach.

But not in a classroom.

I offered myself up to the community education craziness and became an evening instructor in a smattering of strange tries. Floorcloths. Abstract watermedia. Collage. Polymer clay. Basketry. Yeah, I've done a few things over the years ...

I just jumped in there to see what was playing at my heart, in between juggling the boys and volunteering at their schools and working in our family artisan bakery. What fun I was having.

Add five years. We are living in Washington. My brave is just getting braver, and I discover that melting paraffin on the stove top and adding it to my mixed watermedia is not the best thing to do. Without Google's help, I unearthed R&F, took a one-week course and have been on that risky, "have a go" ride ever since.

Pairing my passion for creating to that of teaching has revolutionized my life. It's brought the whole of me together, clicking into place things not before slid home. Inspiring others to their creative voice and to seek out their own passion with hot pursuit drives me in my lowest lows and catapults me in my highest highs.

Teesha Moore of ArtFest fame took a chance on me in 2007; she accepted my proposal to teach encaustic at her annual retreat when she had only heard whispers of it. I convinced her it was real and good and people must see this. I've been waxing and inspiring ever since. Thanks to Tonia Jenny being in attendance that year, I was contracted for *Encaustic Workshop* and the rest has flown out of that start.

ABOUT PATRICIA BALDWIN SEGGEBRUCH

For bonus demos, art and more, visit artistsnetwork.com/encaustic-revelation.

"For some things there is no wrong season, which is what I dream of for me."

—Mary Oliver

Sure, it sounds so fluid and obvious and lucky as I write it here. But none of it was. There are the days of angst at leaving my boys behind so I can go teach a workshop after having been their stay-at-home mom for so very long. There's the anxiety of never quite thinking myself *good enough* or *real enough* or a *true artist* and fearing someone would find out I was a fraud at every turn. There was the ground-shaking divorce and complete life realignment that that manifests. And more, of course. Always more.

Just as disruptive has been the discovering—or finally hearing and accepting—that I am good enough and that I am real. Just as disruptive is the voice, now screaming, inside telling me,"This is good! This is right! This is the piece that fits and is real!" and realizing there is no humility, truly only ego, in trying to deny I do not have something I'm here to share. Just as disruptive (and oftentimes infuriating!) is the tenacious will (where did that come from?!) to keep on going—when painting another stroke, or getting on another flight, or tearing my heart between responsibilities of home and passion seem too much. And there's always the wondering if this is enough, to survive, to thrive, to live my purpose. And there's always the wondering if I am strong enough, bold enough, brave enough to be the carrier of all the ideas and desires and wants that keep spilling from this amazing ride I am on. There's always doubt.

But alas, I don't do much inspiring by listing the struggles that you, too, face. What I hope to do in this listing is make you see: Despite the fact that I face the same struggles, the same heartaches, the same life-altering challenges and self-deprecating doubts and fears, I determine to take another step. Perhaps nothing—absolutely nothing—sets me and my following my passion apart from you and you following yours except that I determine to take the next step.

Risk a potential failure.

Create something hideous.

Experiment with something that doesn't work.

Teach someone who doesn't get inspired.

Each time I go ahead and risk it, take a step into a space that seems to have no ground, I find a foothold. I even, oftentimes, fly.

This is what happens when you live in your passion—when you can't deny the ache it creates in you and you just have to try it; give it; go there; believe in it.

I'm living in where the ache has taken me, and sometimes I have to touch my life and see if it is real (altering and combining the quotes of Mary Oliver and David Rivard to serve my purpose).

We are all born in the creator's image to create.

Have a go.

And while you're at it, ask that creator what he's designed you to create. You just might discover your heart's passion.

In love.

—*Trish*

pbsartist@aol.com | pbsartist.com

ADDITIONAL RESOURCES

Ampersand Art Supply | ampersandart.com
Enkaustikos | encausticpaints.com
Langridge | langridgecolours.com
R&F Handmade Paints | rfpaints.com

PanPastel | panpastel.com
Procion dyes and prereduced indigo kit | jacquardproducts.com
plaster and tar | Home Depot
stencils | stencilgirlproducts.com

Art Supply stores:
While there are MANY more art shops worthy of being listed here, these are just a few I have enjoyed for their abundance of encaustic stock:
danielsmith.com
artspotedmonds.com
fineartstore.com
museartanddesign.com
oxlades.com.au (Australia)
gordonharris.co.nz (New Zealand)
jacksons.com.au (Western Australia)
stlukeart.com.au (Melbourne)

For bonus demos, art and more, visit artistsnetwork.com/encaustic-revelation.

125

index

For bonus demos, art and more, visit artistsnetwork.com/encaustic-revelation.

Other fine North Light Books are available from your favorite bookstore, art supply store or online supplier. Visit our website at www.fwmedia.com.

18 17 16 15 14 5 4 3 2 1

DISTRIBUTED IN CANADA BY FRASER DIRECT
100 Armstrong Avenue
Georgetown, ON, Canada L7G 5S4
Tel: (905) 877-4411

DISTRIBUTED IN THE U.K. AND EUROPE
BY F&W MEDIA INTERNATIONAL, LTD
Brunel House, Forde Close, Newton Abbot, TQ12 4PU, UK
Tel: (+44) 1626 323200, Fax: (+44) 1626 323319
E-mail: enquiries@fwmedia.com

DISTRIBUTED IN AUSTRALIA BY CAPRICORN LINK
P.O. Box 704, S. Windsor NSW, 2756 Australia
Tel: (02) 4560-1600, Fax: 02 4577 5288
E-mail: books@capricornlink.com.au

ISBN 978-1-4403-3295-1

edited. KRISTY CONLIN
designed. BRIANNA SCHARSTEIN
production coordinated. JENNIFER BASS
photography. CHRISTINE POLOMSKY

The photo on page 12 is credited to David Hoffend; courtesy of Enkaustikos.

METRIC CONVERSION CHART

CONVERT	TO	MULTIPLY BY
Inches	Centimeters	2.54
Centimeters	Inches	0.4
Feet	Centimeters	30.5
Centimeters	Feet	0.03
Yards	Meters	0.9
Meters	Yards	1.1

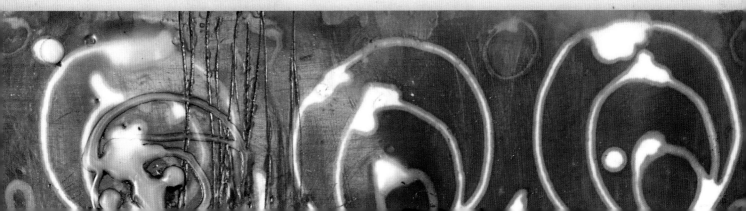

Want more waxy goodness?

We have plenty of FREE *Encaustic Revelation* bonuses to inspire you!

Just go to **artistsnetwork.com/encaustic-revelation** for access to bonus demonstrations, tips , ideas & more!

Visit artistsnetwork.com & get Jen's North Light Picks!

Get free step-by-step demonstrations along with reviews of the latest books, videos and downloads from Jennifer Lepore, Senior Editor and Online Education Manager at North Light Books.

Get involved

Learn from the experts. Join the conversation on WetCanvas